The Photographer's Assistant Handbook

The Photographer's Assistant Handbook

Matt Proulx

Focal Press

Boston Oxford Auckland Johannesburg Melbourne New Delhi

Library of Congress Cataloging-in-Publication Data
Proulx, Matt, 1967-
 The photographer's assistant handbook / Matt Proulx.
 p. cm.
 Includes bibliographical references and index.
 ISBN 0-240-80413-9 (pbk : alk. paper)
 1. Photography-Vocational guidance. 2. Photographic assistants-
 Handbooks, manuals, etc.
 I. Title.
 TR154.P76 2000
 770'.23—dc21 99-087666

British Library Cataloguing-in-Publication Data
A catalogue record for this book is available from the British Library.

The publisher offers special discounts on bulk orders of this book.
For information, please contact:
Manager of Special Sales
Butterworth-Heinemann
225 Wildwood Avenue
Woburn, MA 01801-2041
Tel: 781-904-2500
Fax: 781-904-2620

For information on all Focal Press publications available, contact our World Wide Web home page at: http://www.focalpress.com

10 9 8 7 6 5 4 3 2 1

Printed in the United States of America

Dedication

To my father, Roger Proulx, whose support and confidence made this book possible. And to my lovely wife, Jackie, for all her love and patience.

Contents

Preface

There are very few hard-and-fast rules to being a photographer's assistant. Some things in this book may not apply to all assistants or to every situation, and some may even be contrary to the ways of working that certain assistants have found works best for them. As the saying goes, "If it ain't broke, don't fix it." But if assistants are looking to get started in the business of photography assistance or to improve their skills, and thus get more work, this book will give them the instruction they need to become the kind of assistant that every photographer wants to hire. I suggest that assistants pick and choose among the tips and advice I give for those that best suit their own situations.

I have been assisting for many years now—twelve to be exact. Some of you may think that this is too long, for someone with aspirations of becoming a professional photographer, to work as an assistant. I don't. I enjoy what I'm doing. The photographers for whom I work are fun to be around, and the shoots are often exciting. Over the years I have learned from many different photographers the tricks-of the-trade, the lighting styles, and the business tactics that have helped me improve my business. While deciding on the direction I wanted to take my own photography, I traveled to exotic locations, met famous people, made valuable contacts throughout the industry, and got paid to do it. Assisting is the last chance in this business to learn how each photographer works, firsthand. Lectures and workshops are helpful to scratch the surface, but to get the real, inside information on making a living as a photographer, nothing beats assisting.

I started assisting while I was in photography school, and though I am shooting more of my own jobs now, I still assist to keep money coming in on a regular basis and to learn more about the various fields of photography. Assisting to me is like a buffet table; you can get a little taste of everything. During my years as an assistant I have worked all kinds of shoots: still life, fashion, corporate/industrial, celebrity portraiture, cars, food, beauty, architecture, landscape, in the air and underground, big-budget advertising and low-budget editorial. From each of these shoots I have learned something to improve myself as an assistant and as a photographer.

In twelve years as an assistant you pick up a lot of tips and information. I have been lucky to have had many opportunities in the business to acquire this knowledge. The more I learned, the more other opportunities presented themselves. It's not easy to get started in this business, and harder yet to get the kinds of jobs that you want. That is why I wrote this book, to give inexperienced assistants a shortcut to learning the skills and tricks that it takes to become a successful assistant.

Acknowledgments

No book of this type is created without the help of many people. Those who helped me made this one possible by their contributions, from passing along information, stories, and production photos, to the use of their studio space and assistance. To all the folks who so generously assisted me in doing this book, I would like to express my thanks.

First, I'd like to thank Lauren Lavery at Focal Press for taking me by the hand and leading me through the complicated process of writing this book. She's been very giving of her time and advice.

Photographers Gary Gladstone and Jack Reznicki have helped on so many levels it is hard to know where to begin with expressing my thanks. They have been a constant source of guidance and assistance over the years, and I owe much to them. I am eternally grateful for the use of Gary's production shots of me, and for the use of Jack's studio space for this book. Putting together your first book is a monumental undertaking; their help has made it much easier.

Where would I be without a good assistant of my own? Stephanie Tracy worked hard to help me produce many of the production photos in this book.

To Elyse Weissberg, for her advice to emerging photographers, to the people at The Flash Clinic, and to the folks at Mamiya, I would like to extend my gratitude for their help on this project and others.

1

The Basics

So, you're crazy enough to want to be a photographer's assistant? All right then, I'm going to tell you what you need to know to become the kind of assistant with whom every photographer wants to work. There are a lot of assistants out there scrambling for each and every job, but when you have the right mindset, the right tools, and the right knowledge you can work with any photographer that you want.

What exactly does an assistant do? Well, to put it bluntly, everything. The assistant is there to free the photographer from all distractions so he or she can think only about the photograph. That includes handling all the technical details of the photo shoot, answering the phones, running errands, and sometimes even cleaning the bathroom.

Assisting is not glamorous. The hours are long, the work is physically tiring, and you are the lowest person on the totem pole. But it is the best way to learn the business of photography. Keep your eyes and ears open, watch how the photographer handles the paperwork, the clients, and all the intricacies that go into a successful photo shoot, and then adapt what works into your own business practices.

I asked several photographers what they look for in an assistant. They were quick to answer. Photographers want assistants who are

dependable, professional, punctual, technically proficient, good problem-solvers, have positive "can-do" attitudes, never need to eat or sleep, and can leap tall buildings in a single bound. They expect a lot from assistants. Assistants who can deliver get the jobs.

Getting Started

Mindset

The first thing you need as a rookie assistant is the proper mindset. An assistant is hired to do whatever it takes to help the shoot go smoothly, whether it's working on set or simply running errands. Photographers want assistants who are dedicated to helping them look good to their clients. In later chapters I will tell you how to do all of this. For now, it is just important for you to know that you may have to do a job or two that you think is beneath you, but if you make that extra effort it will pay off. When photographers see that you are ready to help them in any way that you can, they will hire you more often and even refer other photographers to you.

Enthusiasm goes a long way, too. Show photographers that you're happy to be working for them. They like to know that you're not just there for a paycheck, but that you are interested in what they do and how they do it. No one likes to work with a sourpuss.

Walking into a photographer's studio with an attitude about what you will or won't do is the surest way *not* to get hired again. Bad attitude is actually the most common complaint expressed by photographers about their assistants. You're there to solve problems, not create them.

As a new assistant you are not expected to know everything. Asking for help is better than doing something wrong and looking incompetent. If you are unfamiliar with a piece of equipment, ask questions. Then impress the photographer by learning it the first time.

On my first assisting gig I didn't know one end of an 8 × 10 camera from the other, but the photographer was aware that I had never assisted before and was very understanding. Most photographers are. I asked him to teach me what I didn't know, and I learned how to do it without needing to be told again. Learning quickly made up for my lack of experience, and my willingness to do whatever it took to make his job easier got my name on the top of his list of assistants to call.

The most valuable assistant is the one who can anticipate the photographer's needs and stay one step ahead. Once you understand how each photographer prefers to work and the technical needs of a photography set, you should be able to think ahead of the photographer. Solve problems before they are problems. If there is light flare on the lens, set up a gobo *before* the photographer has to ask for it. Nothing impresses a photographer more than an assistant who can stay one step ahead. Remember this.

Tools

Now that your head is in the right place, there are a few tools you should bring with you when you assist. The bare minimum equipment kit an assistant should arrive on set with is a Sharpie, a Leatherman tool or a Swiss Army knife, and an invoice. A Sharpie is an indelible marking pen that will write on most surfaces, and you will use it to label film rolls, Polaroids, and other things. When I first started assisting, every assistant carried a Swiss Army knife, because of the various compact tools it provided. In the last few years, though, Leatherman tools have

matt proulx

P H O T O G R A P H Y

Soc. Sec. #: ###-##-####

Invoice Date:

To:

Date	Job #	In	Out	Reg. Hrs.	O.T. Hrs.	Day Rate	O.T.	Total
						Total Due		

555 Main Street Brooklyn, NY 11223 (718) 555-5555

Figure 1–1 This is the invoice that I use.

supplanted the Swiss Army knife as the tool of choice because of the needle-nosed pliers that fold up inside of it. Both are available at any camping supply store. Lastly, when the job is over, you need to provide the photographer with a receipt or invoice for your services, such as the one in Figure 1–1. Invoices need not be fancy, but they should include your name, address, phone number, Social Security number, and the amount for your services.

I carry one of the most complete assistant kits around. I wear a belt pouch around my waist from which I hang another padded bag. The reason for two pouches is to keep unexposed film in one and shot film in the other to avoid the disaster of accidentally loading shot film into the camera. In the pockets of the padded bag I carry all my tools. The full kit includes: a black Sharpie, a red Sharpie, a fine point Sharpie, a ballpoint pen, a Leatherman tool, a retractable utility knife, tweezers, a small flashlight, scissors, an Allen wrench, a dental mirror, a doorstop, a small pad of paper, a compass, Avery dots, a small fold of gaffer tape, and an old key card from a hotel. One photographer jokes that one day he expects me to pull a rabbit out of there.

It's fairly obvious why some of these tools are in there, but you're probably wondering why I carry things like a dental mirror. Let me run down the list and explain why I carry everything I do.

- Sharpies: I label film and Polaroids with these. The red one highlights important notes. Write your name on your Sharpies. Photographers and clients are notorious for glomming Sharpies.
- Ballpoint Pen: The pens you open with one hand, by clicking the top with your thumb, are preferable. They're also easier to find in the pouch by feel.
- Leatherman Tool: The collapsible pliers and wire cutters make this item indispensable. The screwdrivers in it are also sturdier than those in a Swiss Army knife.
- Retractable Utility Knife: Segments of the blade snap off so you always have a sharp edge. Use these to cut seamless set paper.
- Tweezers: These are good for working with small items on tabletop sets. They also keep my grubby fingers from leaving prints on the product.
- Small Flashlight: It's always handy to have a flashlight around.
- Scissors: Since the Leatherman doesn't have built-in scissors, I carry a pair of kiddy scissors. I get kidded about these quite a bit, but when you get jabbed by a pair of sharp ones through the belt pouch you'll understand why I prefer the ones with rounded tips.
- Allen Wrench: Some photo equipment parts require these little hex tools.
- Dental Mirror: Now this is one of the odder tools that I include in my kit. The dental mirror is small and light and allows me to see areas I can't easily get near. For many years I assisted for a very tall photographer. The mirror allowed me to read the camera settings when they were above my eye level.
- Doorstop: Doorstops are handy for keeping open doors that automatically lock and for protecting extension cords from being cut by slamming doors should you need to run one through a doorway. I impressed the hell out of a client once when I whipped out the doorstop to steady her wobbly chair at lunch.
- Pad of Paper: Hotels frequently have these small pads of paper in the rooms. They're useful for taking notes or lunch orders.
- Compass: Have a compass on you whenever you go on location.

This will help you determine where the sun rises and sets, and it will help you find your way when photographers get you hopelessly lost because they thought they knew a shorter route.

- Avery Dots: These small, round adhesive labels are good for identifying film.
- Gaffer Tape: Take a three-foot length of gaffer's tape and roll it up neatly, sticky side in; then press the roll flat so it will fit easily into your kit. This comes in handy when you're on the top of a ladder and don't feel like climbing down just to get a little tape.
- Card Key: The next time you stay at a hotel, "accidentally" forget to return the plastic card key for your room. It is often quicker to get through a locked door with one of these, than to wait for the person with the key. When you've blown a fuse and no one can find the key for the electrical closet an old hotel card key can get you in quickly, and they are more flexible than credit cards.

Though some assistants are of the opinion that a photographer's vest is cliché and a bit goofy looking, I find it indispensable on location. You can never have too many pockets. The vest allows you to carry around odds and ends of equipment, saving you repeated trips to the equipment cases. Of course, at the end of the day I spend ten minutes going through all of my pockets looking for the lens cap.

Assistants need to be accessible to their clients even when they are working for another client, so owning an answering machine or service, a pager, and even a cell phone are crucial. Having a pager allows your clients to reach you faster, and owning a cellular phone permits you to call back from almost anywhere. In most cases the photographer will call several assistants for the same job. The first one to call in gets hired.

An answering machine enables the photographer to update you on call-times, the hour at which the photographer requires you to arrive for work, and other details of the shoot, so check it regularly. Buy an answering machine that you can access remotely and that has a "toll-saver" function. The toll-saver lets you know before the machine picks up if you have any messages, so you can hang up and avoid long distance charges if there are no messages.

Because I work mainly on location, my cell phone and answering machine are my lifeline to my business. While out in rural Arkansas, I can book next week's gigs with a photographer directly on my cell phone and get updates from my answering machine. It eases my photographer's anxieties to know that I'm always in touch.

The last item I consider a necessary tool for any location assistant is a wind-up alarm clock. Why a wind-up clock? No batteries that can go dead in the middle of the night. Never trust a hotel clerk to make your wake-up call on time or the alarm in the hotel room to work at all.

The most important tool, however, is a quick mind. The assistant who can think ahead is an asset to any photographer. Learn to anticipate the photographers' needs, and stay one step ahead. Set up the equipment that the photographers will need *before* they ask for it. Part of knowing how to do this is understanding the workings of a photo shoot, but the other part is learning the style and preferences of each individual photographer for whom you work. After working for a photographer for a while, a good assistant should be able to anticipate a photographer's needs and act upon them instinctively.

Having a killer résumé is not as critical as most assistants believe. When assistants are first starting out they are often afraid that their résumés are on the thin side. Don't sweat it. Résumés hold less

Matthew Proulx
555 Main Street
Brooklyn, NY 11223
(718) 555-5555
Pager: (212) 555-5555

<u>**Objective**</u>:	To obtain a position as Photographer's Assistant.
<u>**Education**</u>:	School of Visual Arts
	209 East 23rd Street
September 1986	New York, New York 10010
- May 1990	
	<u>Degree</u>: Bachelor of Fine Arts in Photography.
	<u>Honors</u>: Fourth Place
	Best of College Photography: 1990
	Photographer's Forum Magazine
<u>**Work Experience**</u>:	Gary Gladstone
	123 First Street
August 1991	New York, New York 10003
- Present	
	<u>First Assistant</u>: Assisting Corporate/Industrial Photographer in the studio and on location, including international travel.
August 1992	Nancy Brown
- Present	1 South Street
	New York, New York 10003
	<u>Freelance Assistant</u>: Assisting Advertising Photographer in studio and on location.
August 1990	Jack Reznicki
- August 1991	23 Second Street
	New York, New York 10012
	<u>Freelance First Assistant</u>: Assisting in the studio and on location, propping, and casting for People Illustration Photographer.
<u>**Skills**</u>:	Black & white processing and printing; color and cibachrome printing; 35mm, 2 1/4, Mamiya 6x7, 4x5, 8x10 camera formats; Balcar, Broncolor, Comet, Dyna-Lite, and Speedotron strobes; tungsten lights, casting, scouting, light carpentry skills, working knowledge of MacIntosh computers.
<u>**References**</u>:	Available Upon Request.

Figure 1-2 Names and addresses have been changed to protect the innocent. Track down your own photographers; these are mine.

References:

Gary Gladstone
Gladstone Studio
(Corporate Photography)
123 first Street
New York, NY 10003
(212) 555-5555

Bruce Buck
Bruce Buck Studio
(Fashion Photography)
24 Fashion Ave.
New York, NY 10011
(212) 555-1234

John Wilkes
John Wilkes Studio
(Still Life Photography)
26 Made-up Street
New York, NY 10001
(212) 555-4321

Jack Reznicki
Rez-nick-i Studio
(People Illustration Photography)
23 Second Street
New York, NY 10012
(212) 555-6543

David Langley
David Langley Studio
(Advertising Photography)
802 First Street
New York, NY 10019
(212) 555-5551

Nancy Brown
Nancy Brown Studio
(Advertising/Fashion Photography)
1 South Street
New York, NY 10011
(212) 555- 7654

Michael Mazzeo
Michael Mazzeo Studio
(Still Life Photography)
786 Half Street
New York, NY 10003
(212) 555-0987

Figure 1-3 Don't fret if you don't have many references, everyone has to start somewhere. Again, the contact information is fictitious.

importance in this business than in most others. Photographers understand that everyone has to start somewhere. Some even prefer to hire inexperienced assistants so they can train them in their own way.

I got started the easy way. While riding on the subway in New York City with my school portfolio, another passenger asked if I was an assistant. He turned out to be a photographer looking for an assistant for the next day. Admitting that I had never worked as an assistant before but that I was eager for a chance to start, we talked about my experience with strobe and camera systems and what photography skills I had; both were very limited. My enthusiasm was what finally clinched it, and the next morning I was an assistant. He helped me lay out my first résumé, and as crude as it was, it was all that I needed.

I've seen all types of résumés sent to photographers. The worst one that I was shown was handwritten on a yellow sheet of paper torn from a legal pad. Others were attempts at attracting attention by using colored paper or creative designs. Don't bother with that. Keep it simple and to the point. Type it clearly and neatly following a standard form. The sample résumé in Figure 1–2 is an old one of mine.

If you haven't worked as an assistant before, include any work experience you've had that might be useful to a photographer. Again, don't fret over your lack of experience. Use your interview with the photographer to impress him or her with your energy and enthusiasm.

Include a page of references like the one in Figure 1–3, listing the photographers who will give you a good review. Ask their permission before you place them on this list. Their answer should give you an indication of what they think of you.

Portfolio

Great portfolios are not essential to getting assisting work either. Photographers look at your book to get a sense of your technical skills—and often, just out of politeness. You're there to assist, not shoot. Have your work with you neatly presented, but expect that it will count only as much as any other part of your interview with photographers.

The first time a photographer passed on looking at my book I was devastated. But he explained that he wasn't looking for a photographer, he was looking for someone who could lug his equipment around for him. That gave me a good perspective on assisting.

Now that the basics are out of the way, you're ready to learn how to get the assisting jobs that you want, and the ones that will teach you what you want to know about photography. Assisting is all about learning. Being a good assistant gives you access to the information that you want to make yourself a better photographer. That's the payoff.

2

Getting Work

Now that you have all of your assistant's tools and your head is in the right place, you need a photographer to hire you. Simple, eh? Don't you believe it. Getting work as an assistant is as daunting a task as learning how to be an assistant.

Finding Photographers

First, as aspiring assistants, you need to do a little research. Find out who the photographers are in your area and what type of photography they do. Then decide which ones you want to work for. This may be determined by your interests as a photographer, such as wanting to work for still life photographers because that is what you like to shoot yourself, or by your attraction to the photographer's work regardless of your own photography.

When I first started assisting I worked for anyone who would hire me. Not knowing what type of photography I wanted to do professionally, I wanted the broadest range of experience that I could get. Though my interest was in still life photography when I was in school, I knew there was much that could be learned from the other specialties, so I was determined to assist for as many other types of photographers as possible.

Okay, so how do you find the photographers and see what they shoot? Open a magazine. Look at photography sourcebooks like *The Workbook* and *The Black Book*. Go to galleries. Join photographer's organizations like ASMP (American Society of Media Photographers). Look for photography that excites you and then track down that photographer. Make a list of the people you want to assist and put their names into categories like the ones below:

1. I love their work and want to work for them.
2. They shoot the type of photography I want to specialize in. (You'll learn more about shooting fashion from a fashion photographer than from a still-lifer.)
3. Who cares what they shoot; I need the money.

Ideally you should go after the photographers whose work interests you the most first. Unfortunately, it usually works out that every other assistant in your area wants to work for them too, so you may have to fall back to your second list. Whatever your area of interest, fashion, still life, industrial, and so on, approach the photographers in your market who shoot the type of photography that you want to shoot. There are ins and outs to every specialty that you can learn best from shooters working in that field.

Don't limit yourself only to these photographers, though. There's much to be learned from all of them. As I said before, your interests may change. Mine change all the time. When I first went to school I wanted to be a photojournalist. By junior year I wanted to shoot still life. After graduating, I changed my mind monthly, depending on which photographer I was assisting at the time. As a side benefit to working for so many diverse photographers, I learned tricks from each that I could implement on other shoots for which I was assisting. A simple trick to one photographer is an amazing feat to another.

The last category can produce some pleasant surprises. I've worked for a lot of photographers for no other reason than the fact that I needed money, but I often came away from the experience with a perspective I would never have seen had I stuck with my chosen specialty. Not every experience was a good one, but the bad ones had their uses too. Learning what *not* to do is as valuable as knowing the right things to do. And who knows, you just might like assisting them.

The easiest way to get assisting jobs is to let the photographers find you. I'm all for letting someone else do the work of getting my foot in a

photographer's door. What I'm talking about are referrals. Much of this business is done by word-of-mouth, and once you make a reputation for yourself as a quality assistant, opportunities start to present themselves. After my second year of assisting, all of my work has come through referrals.

Photographers do, on occasion, speak to each other. When they do, a common topic is assistants. A good assistant's name can get passed around to many photographers. The name of an assistant carries more weight with a photographer when another shooter has given that assistant a "seal of approval" than when it arrives on an unheralded résumé in the mail. This should be lighting all those light bulbs over your head telling you to do everything you can to impress each photographer that you work for, because you don't know which one will refer you to that next big job.

Photographers also listen to recommendations given by other assistants whom they trust. When you work with other assistants, get to know them and trade phone numbers. They just may mention your name to their other photographers. You should be prepared to do the same if—and that's a big *if*—they're good. When you refer another assistant to a photographer, your reputation is on the line. Make sure he or she is not going to let you down. This goes the other way around, too. Don't ruin the good work you've done with your photographers by letting other assistants see you goofing off, because you never know if they will mention your lapses to others.

Many of the photography trade organizations, like APNY (Advertising Photographers of New York), have lists of assistants that they distribute to their members. These lists detail the assistant's experience and skills so that the member photographers have a pool of assistants to call. If your local group has one, get on it. I've gotten quite a few calls over the years because of my being on this list. Don't rely too heavily on these listings, though. They get you the occasional gig, but they won't pay your rent.

Another place that photographers look for assistants is directly from the photography schools. Check your school's Alumni or Jobs Office. This is a good place for newer assistants to start looking for jobs. Most photographers advertising here are looking for young, inexperienced assistants, and are willing to train them.

If photographers are not beating a path to your door, you're going to have to go out and look for them. There are a few basic ways to track them down, all of which you should do regularly. Though you may be working with one or more photographers consistently, you don't want to be caught flat-footed if their businesses get slow or they move on to other assistants. Just as photographers don't want to rely on just one client, neither should you. So always be on the lookout for new clients.

Some photographers looking for assistants make it easy for you to find them. They take out help-wanted ads. Check the classified sections of your local newspapers and trade magazines like *Photo District News*, also known as *PDN*. I got my best client from the classified section of *PDN*. I had seen a lecture he had given at an APA (Advertising Photographers of America) meeting and liked his work. Several days later I saw a help-wanted ad that he had placed in the back of *PDN*, so I called him. We hit it off immediately, and I've been working with him ever since.

Joining photography trade organizations, like ASMP, APA, and APNY, is a great way to meet photographers. These groups usually have monthly meetings or events that attract shooters from all over

your area. Take advantage of the fact that the room is full of photographers. Apart from being a great way to gather information about the business of photography, these get-togethers provide ample opportunities to schmooze your way into assisting jobs.

Schmoozing is an art form. You have to be smooth about hitting up photographers for work at these meetings. Don't look too eager or "drool." Never interrupt a conversation; wait for the proper moment to introduce yourself. Make polite conversation for a bit. If you're lucky, the photographer will ask what you do. That's your cue. Make your pitch, but be cool about it. If they don't give you an easy opening, you'll just have to work it into the conversation.

It helps if you know the photographers' work. Tell them you've seen their work and like it very much. This is not always true, but they like to hear it. Then, tell them that you've wanted to get in to see them about assisting for them, and ask if it would be all right if you called to set up an appointment. That said, exit gracefully and start breathing again. I don't hand them a business card unless they ask for it. Personally, I find that kind of tacky, and the card usually just sits in their pocket till they throw it away.

At first I was not very good at striking up conversations with strangers, but desperation has a way of making one capable of anything. After a dry spell early in my career, I decided that I had better get over my nervousness and take advantage of having photographers all around me at these meetings. I volunteered my time to work for the APA-New York Chapter and worked the door and front desk at meetings. Photographers grew accustomed to seeing me and even began to chat with me. I used this familiarity as an opportunity to get interviews with them. It wasn't long before I was assisting for most of the board of representatives for the Chapter.

Attending workshops, such as the ones given during the big regional photo expos, are perfect opportunities to make connections. The photographers on stage are expecting to be chatted up by the audience afterward, and the audience itself is full of photographers with whom you can schmooze. Aside from viewing a large portion of their photographs, which should give you a good idea of what they shoot and how they work, try to get a read on the personalities of these photographers. They may be great photographers, but if they're not forthcoming with information or seem difficult to get along with you may want to rethink assisting for them. Remember that you're assisting to learn from the photographer. "Clicking" with the photographer personally has much to do with how well you both will work together, and how beneficial assisting for this person is going to turn out for you. Going to these workshops gives you a sneak peek into what these people are really like before you approach them for assisting work, so you can make allowances accordingly.

Back when I first started assisting, I forked over the cash and went to several of these expo workshops. One photographer in particular caught my attention. He had a beautiful lighting technique and the sense of humor that he worked into his images compelled me to approach him after he finished his show. On stage he seemed friendly and easygoing, so I swallowed hard and waded through the crowd to make my pitch. I told him I loved his work and would like the chance to assist for him. Okay, so I gushed a bit, but it worked.

The next week I went to his studio. He politely looked at my portfolio and after a brief interview he decided to give me a try. I busted my butt to impress him, and after several shoots as his second assistant, he

hired me as his first assistant. We have worked together now, on and off, for over nine years.

This photographer has been one of the biggest influences in my life. He has always been helpful with technical and professional advice, and through working with him I have made numerous contacts that have advanced my career both as an assistant and as a photographer. Working up the courage to speak to him after his lecture was probably the best thing I've ever done for my career. The least time-consuming way to find photographers is to browse the photography sourcebooks. Companies like *The Workbook* and *The Black Book* put out large directories listing photographers and their phone numbers and samples of their work. Get hold of one of these and thumb through it. If any of the images catches your eye, put the photographer on your list to call.

When you've tried all of the above and are still not getting enough work, it's time to "shotgun." This is the least effective method of getting assisting work, but desperate times call for desperate measures. "Shotgunning," called this because it's a scattershot approach, entails going through the sourcebook directory of names and calling photographers one by one until you get a favorable response. It's pretty much hit or miss, and you will have a huge phone bill at the end of the month. But all you need is a couple of regular clients to get you through until you can land that job with one of your photographers of choice.

Try calling all of the photographers who specialize in your field of interest first, then branch out to the others. One suggestion I make to the assistants in my workshops is not to start at the beginning of these alphabetized directories. Skip to the middle and call the photographers whose names begin with "M" and continue through the rest of the list. So many assistants shotgun from the beginning of these directories that the photographers here are rarely in need of new assistants and are probably tired of getting calls from them.

Be prepared for rejection. You'll make a lot of calls, but very few photographers on the whole list are currently looking for new assistants. Most won't even answer their phone. Don't leave a message; it won't mean anything to them, and they'll just ignore it. Many will tell you they're not hiring. Ask them if it would be okay if you sent them a résumé for their files. If they say no, scratch them off your list. For those who do tell you to send a résumé, put one in the mail and then follow up periodically with phone calls. I'll tell you later how to do this without being a pest. Timing and luck have a lot to do with getting assisting work this way. You just have to keep at it and hope you catch the photographer in a good mood and at the right moment.

Telephoning a photographer with whom you've had no previous contact is known as making a "cold call." These calls are awkward and very few people are comfortable making them. Get used to it. You will be making tons of them to art buyers and photo editors when you later become a photographer. Try writing out on paper what you want to say first and then practice saying it to yourself a few times until it sounds right. I was a very timid person when I started making these calls and was sure that I sounded like a moron every time I got a photographer on the phone, but after the first few dozen I relaxed and no longer needed to refer to my cue cards.

Keep your pitch simple. I simply said, "Hi. My name is Matt Proulx. I'm an assistant. I was wondering if you had any openings." It may sound like an Alcoholics Anonymous meeting, but it was all I could manage to say without tripping over my tongue. The photographer at this point will say one of several things: "I'm not hiring right now"; "I don't

use assistants"; "Send me a résumé"; or "When can you come in for an interview?" Arrange any interview at the photographer's convenience. If you are turned down ask, "Do you mind if I send a résumé anyway for your files, just in case?" Most will accept, even if only out of politeness, but who cares why, just as long as your name gets in front of them.

Following up on these calls, and all contacts for that matter, is crucial. I'll say it again so it sinks in: follow-up is crucial. You can't expect any photographers to remember you from one phone call or meeting, so you will need to check in with them occasionally to let them know you're still alive and interested in working with them.

I recently attended the graduation ceremony of a photography school for which one of my photographers was the keynote speaker. During the reception afterward, despite my icy stares designed to scare off any potential competition for my job, several graduates schmoozed my photographer. Torn between protecting my "meal ticket" and pride in seeing young assistants take the initiative, I watched them make their pitches. They did well. The photographer let me know later that should the need arise, he would consider using them.

A month later while working with this same photographer, and needing some extra help, I suggested to him that we call in some of these graduates to give them a chance. To my dismay, none of them had followed up on the opportunity given them at graduation. Not one had called the photographer or sent a résumé. What a blown chance! A single phone call or a postage stamp could have gotten their foot in the door of a very busy studio.

Knowing how often and when to call is tricky. You don't want to appear pushy or become a pest. As a rule of thumb, I wait a week after photographers receive my résumé, to give them a chance to look it over, before I call. When I do call I ask if they received my résumé, if they have any questions, and, if we haven't met face to face, if they have time to meet with me. Whether or not I get an interview with them I ask them to keep me in mind should any work come up. For the first month I call once a week, just to check in and see if they have anything for me. If they don't, I say, "Thanks anyway," and ask them to keep me in mind. When that first month has passed and I haven't gotten any bookings, I call less often, in two-week intervals, just so they remember who I am. After the third month has gone by and they haven't hired me, I stop calling and move on.

The Interview

Interviews are less traumatic than they seem. The average one lasts less than ten minutes. The photographers will want to know how much experience you have, and will be trying to get a read on how well you both will work together. You, in turn, are also secretly interviewing the photographers, getting to know them and how they work to decide whether you want to assist them.

Stay flexible when you go in for an interview, because just about anything can happen. I've been on interviews that went better than I could have hoped and the photographer hired me on the spot, and others that I wish I had never been on. One of the worst was with a photographer who had a working relationship with my father. I noticed he was uncomfortable with the idea of hiring a client's son, so I let him off the hook and left the interview quickly, never pressing him for work. The oddest interview lasted for over two hours, during which the photog-

rapher and I finished off a six-pack of beer that he pulled out of his refrigerator.

Let's say you've made a successful cold call and scheduled an appointment with a photographer for an interview. What now? What is going to happen at the interview? What questions will the photographer ask? Should I bring my portfolio? How should I dress?

Just as with any type of job interview, you want to be dressed neatly. You don't have to dress up in a suit, thank goodness, but you want to appear as though you at least know how to tie your own shoes. Your personal appearance will partly form the photographer's first opinion of you, so don't work on your car's engine two minutes before your interview. I'm not advocating any particular mode of dress, but merely pointing out a basic human instinct to make snap judgements about people by their appearance. Personally, I wear a clean T-shirt and jeans to interviews.

Bring a copy of your résumé and references with you. Even though you've probably already sent them to the photographer, have another copy on hand for easier reference. Most photographers will have either thrown your other résumé out the day they got it in the mail or shoved it deep into a file cabinet somewhere, so have a new one that you can give them during the interview.

Though nearly all photographers will be polite and look at your portfolio, it's not as important as your skills as an assistant or your willingness to work your butt off for them. Showing your portfolio is standard practice, but the photographer is only looking at it to determine that you know one end of the camera from the other and to discover your area of interest in photography. They're not really interested in your skills as a photographer. You're there to work for them. As one gruff food photographer once told me in an interview, "I don't care if an assistant is a good photographer, I want to know if he's going to clean my toilets." That was a bit deflating, but it helped me remember why I was there. So bring your portfolio, expecting the photographer to give it only a cursory glance.

When you enter the studio take a look around. Look for samples of the photographer's work on the walls to get an idea of which images she is most proud. Check for the type of equipment in use. Use your eyes to learn as much as you can about the photographer and the way that she works, so you can use that information to tailor your interview, putting yourself in the best light possible. By that I mean if you see that the photographer is using a certain type of strobes or camera, you can mention that you are familiar with using them. In fact, it's not a bad idea to ask the photographer what kind of equipment she uses, but don't panic if you haven't worked with it yourself; most photographers are willing to teach you how to handle their gear.

Each shooter interviews assistants differently depending on her personality and needs, but you can expect certain questions to pop up. "How long have you been assisting? What cameras and strobes are you familiar with? What is your day-rate?" Answer the questions in a concise manner; keep your answers short and to the point. This is your first chance to impress the photographer with your professional manner, so be confident and forthcoming. It is important not to exaggerate your abilities. You don't want to be put into a situation where you'll be asked to perform a task that's beyond your skills and have to admit that you lied. It's not a crime to be inexperienced; you can't know everything.

Now that the interview is over you can breathe a sigh of relief, go home, and arrange the next one with another photographer. Get in to

see as many photographers as you can. This process will get easier every time you do it, so you may want to start with photographers further down on your list for practice. Once you've got the hang of it, call the people you really want to assist.

If a week has passed since your interview and you're wondering what to do now, I'm going to smack you in the head. What did I say earlier in this chapter about following up? Make your follow-up call. Remind the photographer about your interview last week and say that you were just calling to see if anything had come in that might be suitable for you. Don't sit back and wait for them to call you. Check in from time to time so that they remember who you are and they know that you are available.

Many times I've caught photographers just as they were about to start calling assistants for a job that had come in. Because I was on the phone with them at that moment, I got the job.

3

Checklists

One of the scariest moments of your career is standing outside the front door of a studio on your first assisting job. A thousand questions are buzzing through your head. "What should I do first? What is expected of me? Why am I here?" Knowing what to expect will at least keep your knees from knocking.

Every day as an assistant is a little different, so an assistant needs to be flexible. Each photographer works a little differently from the next, and the requirements of each shoot can differ greatly. The photographer for whom you're working will prompt you on any specific needs, but there are some procedures common to most photo shoots of which you should be aware. This chapter provides you with general checklists, which you can follow to help you understand what you should do and when to do it.

Knowing what to do on a photo shoot starts when the photographer calls you to book the day. Ask questions. Find out everything you can about the day ahead of you. Often, the photographer has few details and can only give you sketchy information, but get as much as you can. Depending on the photographer's specialty, you may want to ask some or all of these questions:

- What are we shooting?
- What time do you want me there?
- Are we in the studio or on location?
- Do you prefer that I dress a certain way?

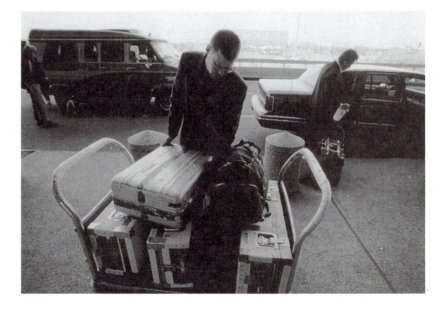

The first three are pretty standard questions. Their answers should give you a fair idea of what's ahead, but the last one is often overlooked. Some photographers prefer that you dress a certain way on their shoots. Many corporate photographers require that you wear business attire, which means a sport coat and necktie for men, a blouse and slacks for women. Or, you might get lucky, and the photographer will tell you to "dress down." If so, anticipate some messy chores like painting the studio or climbing up into overhead storage compartments to find that prop that hasn't been seen in years. Either way, you want to be dressed appropriately.

I've worked with a corporate shooter for many years who insists on our dressing to blend in with the business executives. That means a necktie. I hate ties. I must have ruined ten ties over the years by catching the ends of them in the zippers of equipment cases, which means that I have to go out and buy *more* ties.

I've separated the following checklists into two main categories, studio and location, for easier reference. They're arranged in an order that will help you stay on top of things, but the circumstances of the shoot may require you to improvise and alter this order. Remember to stay flexible and follow the photographer's directions.

Studio Checklists

Arriving at the Studio
- Ask the photographer for more details about the shoot to determine what equipment you will need to set up and how much film to get ready.
- Look around. Find out where everything is.
 1. Power outlets
 2. Camera equipment
 3. Camera stand or tripod
 4. Stands
 5. Lights
 6. Showcards
 7. Cords and grip equipment
 8. Cleaning supplies
- Is the unexposed, or raw, film laid out ready for use? If not, ask the photographer about it. It may need to be taken from the refrigerator and need time to thaw.
- Do a quick clean-up, if necessary. Check the general condition of the studio. If there is time, give the floor a quick sweeping. Tidy up the place. Photographers love this.
- Check the set-cart or work area for dust. The set-cart is a rolling tool chest on top of which you lay camera equipment, so it must remain dust-free at all times to avoid getting dirt inside cameras or on the film.
- Finally, start setting up some light stands. By that time, the photographer should be directing you as to what equipment will be needed for the shot and where it should all be placed.

Pre-Shoot Checklist
- Check inside the camera for dust or hairs. Make sure the camera is empty of film before you open it.
- Are lenses and filters clean?
- Strip some film (remove its packaging) and have it ready to load into the camera. Don't strip all of it in case you use less than anticipated. You can always open more, as it is needed.
- Have Polaroid film ready.

- Load cameras, backs, or sheet film holders. Be methodical when loading 4×5 or 8×10 sheet film into holders in a darkroom. It's easy to lose track of things in the dark. I always place the box of unexposed film to my left, the film holders in the center, and the box for exposed film to my right. Set it up any way that works for you, but do it the same way every time. Distractions can quickly confuse you as to which box has the shot film. Don't turn the lights back on until all film boxes are closed.
- Are all strobe heads firing? Visually check the heads. Some strobe power packs have audible recycle tones indicating that they are charged and ready to fire. Count the beeps so you can tell that the strobes are all firing when you are not able to check each one visually during the shoot.
- Take meter readings.
- Any light flare in the lens? If so set up a gobo or cutter card to keep the light from shining on the lens.
- Check through the camera to see if any stands or other equipment show in the frame.
- Have the data sheets ready.
- Both unexposed film and shot film should be protected from direct lighting. Shade your work area or move it.
- Check that any gels on lights are secure.
- Keep cords neat or taped down so no one trips over them.
- Know where extra equipment is in case something breaks during the shoot so you can replace it quickly.
- Is the camera synced to the strobes? Check the connections. The sync cord gets detached frequently during shoots for many reasons, so check it often.
- Confirm that the camera is set for proper exposure. Check it yourself. Many photographers rely on the assistant to set the exposure.

Shoot Checklist

- Check periodically that all strobe heads are firing. If not, tell the photographer immediately.
- Check camera exposure periodically. It gets bumped off setting every so often.
- If the camera is moved, check for lens flare again.
- If the models or subjects move off their spot unintentionally, get them back to it. If the model is intentionally moved, be prepared to make exposure or strobe power adjustments.
- Be ready with film or a loaded film back when current roll is almost done.
- Quietly let the photographer know when the current roll is near its end. (Some photographers don't want to make changes to the shot or subject when the roll is almost finished. Don't make a big deal out of it, just inform them when they are on the last frame.)
- Keep an eye open whenever people go on set, in case they trip over a stand or cord. (Stylists are notorious for rushing onto set and tripping over things. Be ready to catch whatever they knock over.)
- Label film clearly by number or letter, however the photographer prefers.
- Make accurate, detailed notes on the data sheet about each roll shot, including meter readings, exposure, descriptions of the shot, and any changes. Listen for the photographer saying anything special about the roll, such as "Clip this one," "This is great," or "Push this $+\frac{1}{2}$." These notes will later determine how the film is processed.

19

I can't emphasize enough the importance of accurate film notes. The information you write down about each roll of film allows the photographer to identify what is on every roll and how it was exposed so that each one can be properly processed. Also, any mistakes can be quickly discovered and the appropriate corrections made.

One of the first photographers I worked for created the simplest, most clearly laid-out data sheets that I have ever seen. I adopted that layout for myself, a sample of which can be seen in Figure 5–1, and presented it to my other photographers as a better alternative to the data sheets that they were currently using. I even went as far as to print them out on my computer with their names at the top, and they went bonkers for it. They praised me for my ingenuity and my concern for their businesses. In truth, I think they were more jazzed about my having printed their names on it.

Post-Shoot Checklist

- Turn off any hot lights. They will need time to cool before they can be touched.
- Power down the strobes in the proper manner for the type in use.
- Ready all film for the lab. Package the film as the photographer instructs. If you take the film to the lab, remember to keep it out of direct sunlight.
- Put cameras away as soon as possible. Accidents happen, and you really don't want something knocking over the camera.
- Strike the set. Put away breakables first. Return all equipment to its storage area. If the photographer is a slob, this is a good time to make a good impression and create some order out of the workspace. Confirm with the photographer that it's okay to strike.
- Take down any background paper or canvas backdrops last. Their size and the awkwardness of carrying them invite disaster. Be careful not to knock things over.
- When everything is put away, sweep the studio floor. If you are feeling ambitious, ask the photographer if it should be mopped as well.

Time to Go

- Fill out your invoice.
- Get paid. The standard procedure in this industry is that the assistant gets paid at the end of the last day of a shoot. In a later chapter I will go into more detail about this often-troublesome aspect of the business.

Location Checklists

When a photographer books you for a location shoot, find out whether you will be indoors or outside. If working outside, check the weather report before you leave your home and wear the appropriate clothing. Wear more layers of warm clothes than you think you'll need when working out in the cold, and wear loose-fitting clothing that breathes when working in the heat.

Working on location has its own set of skills for an assistant to master. Though the shoot itself can be identical to a studio shoot, the added dynamic of having to do it all away from the photographer's studio often creates more responsibilities for the assistant. In addition to the usual duties, the assistant must ensure that everything necessary to the shoot arrives on-site, and then makes it back to the studio when the shoot is done. The following checklists will give you an idea of what you should be aware of when going on location.

Before Departure

- Check with photographer about what equipment is coming with you. It helps to run through a checklist of equipment, even if it's just off the top of your head.
- If the gear is packed already, take a peek inside the cases to confirm the photographer hasn't missed anything, like sync cords.
- If the gear is not packed yet, pack it in such a way that none of the gear slides around in the cases. Even when gear is in padded cases, bouncing around can damage equipment.
- Count the number of cases and loose items like ladders and luggage carts.
- Just before you leave the studio, confirm that the photographer has all of the necessary paperwork in possession. That includes airline tickets, directions, and contact information.

Departure

From this point on, until every piece of equipment is safely back in the studio, none of it leaves your sight or immediate control. Leave nothing unattended on the sidewalk when loading equipment into vehicles at the curb. Be aware of who is around you at all times in case they have some thoughts of their own about where the camera bag is going.

This is not just "New York paranoia." Any time you go on location it is a possibility that someone may try to walk off with a case. It's better to be safe than sorry when your job is on the line.

Any time you move the equipment, count the cases. It's a good way to confirm that you have everything. Another rule of thumb is to make the camera cases the last bags you take out of the studio and load into the car, but the first ones you remove from the car. That way the cameras are in your direct control as much as possible.

Location Arrival

- Keep your eyes open for anything that may be useful to the shoot, like items that might make interesting props. Certain areas that you see at the location might be worth suggesting to the photographer when scouting for a spot in which to shoot. Knowing where bathrooms are located is also a big plus.
- Look for power outlets.
- Find out what time a freight elevator closes, if applicable.
- Find the fuse box if possible, just in case.
- Plug lights into separate electrical circuits if possible. Not every location is wired as well as a photo studio.
- Put all the equipment and cases in one area to minimize the chance of losing something, and to keep the set neat and orderly.

Now that you're set up at the location, do what's applicable from the previous checklists for your pre-shoot, shoot, and post-shoot routines. When the shoot is completed and the set is struck, pack it all back into the cases the way they were originally packed. It's not always as easy as it sounds. For some reason, equipment rarely fits exactly the same way twice, but do your best. Just before you leave, do what's called an "idiot check." Look all around the area of the shoot, carefully. If you find something you might otherwise have left behind, you're an "idiot"—but it's better than being a "schmuck" for going back to the studio without it.

After tidying up and putting everything back the way it was when you arrived (furniture, etc.), you're ready to head back to the studio. Use the same procedure you used when leaving the studio. Count the

cases. On the way back, however, you must have tight control over the shot (or exposed) film as well as the camera bags. The "shot film" should always be at hand. In many cases, it is more valuable to the photographer than the cameras, so have it on you at all times until it is safely in the studio.

After a while these procedures will all be second nature to you, but in the meantime take these lists with you and refer to them when needed. They just might save your butt.

Photographers all have their own way and order of doing things. When in doubt, do it their way. Remember, it's the photographer's shoot and he or she is the boss.

4

The Assistant/Photographer Relationship

The assistant/photographer relationship is one of the most important aspects of this business, but also the most overlooked and least spoken about topic. The most skilled assistant and the greatest photographer in the world can be disastrous together if the chemistry is wrong. This relationship encompasses more than just a worker-and-boss arrangement in which the photographer tells the assistant what to do and when. They both must work together as a team to be successful, and part of being successful is understanding each other and respecting the other's part in the business. Competence at the mechanics of assisting is only a portion of this business. Learning the proper way to communicate with and service your client, the photographer, as well as the photographer's clients, makes a good assistant a valuable asset and an indispensable tool of any photography enterprise.

As in any relationship, we all have roles to play. Accepting your part as the assistant means that you have agreed to do whatever it takes, within reason, to make the photographer's shoot a success, and to help

him look good to his clients. The last thing a photographer wants is an assistant who grumbles about having to perform certain duties that the assistant feels are demeaning. If you want this guy to keep hiring you, it only makes good sense to do what he wants and to do it in the way he wants it done, without complaint. You may not agree with how a particular photographer does things, but remember, it is his business and he runs it the way he wants. The smart shooters are open to suggestions, but in the end, it's their call. Pushing your opinions can create a contentious environment that can lead the photographer to stop hiring you to avoid the hassle.

Servicing Your Photographers

Part of being a successful assistant includes servicing your clients, the photographers. Being a photographer takes intense concentration directed at making an image, so the job of being hospitable to the photographer often falls upon the assistant. Photographers are often so intent upon making a photograph that they ignore their own personal needs to the point of physical distress. An assistant should be aware of this and make the attempt to keep the photographer comfortable whenever possible. Simple gestures like offering to get the photographer a drink of water or a place to sit while waiting for the make-up stylist to finish with the model mean a lot. A happy photographer is a grateful photographer.

Servicing your photographer shouldn't be viewed as menial labor, just good client relations. It's also a clever way of masking the desire to satisfy your own needs. For example, shooting in hot weather is thirsty work. By asking the photographer if she wants some water, you exhibit your concern over her well-being, which should impress her, but it also gives you the opportunity to get some for yourself without the photographer wondering where you went. It's also just plain old good manners.

Keeping the photographer comfortable shows that you are thinking on more than one level about how to help get the shot. Back and knee pain from crouching or kneeling behind the camera is a common complaint among photographers, and those who suffer with these aches and pains find it very distracting while trying to shoot. If the photographer is in a position that puts stress on these areas, look around for something soft to kneel on (a rolled up towel will do), or to sit on, such as a chair or an apple box. More than likely you will be asked for one of these anyway, so it makes you look good to be one step ahead.

On one particularly hot, sunny day I was working as the only assistant on a fashion shoot. We were outside in an open field without any shade, and the sun was brutal. Not having enough hands to do everything, I decided to put up a gobo to shade the lens from the sun so that I could take meter readings and load film. Instead of setting up the standard black gobo card on a stand next to the camera, I pulled out an unused strobe umbrella and clamped that to the stand, hanging a sandbag from the stand to keep it from tipping over in the wind. The umbrella was large enough to shade both the lens and the photographer, giving him respite from the sun. Boy, did he love that! He thought I was a genius. He was so impressed that I had thought to keep him cool so that he could concentrate more on the image, as well as shade the lens, that he started hiring me regularly, choosing me over his usual assistants.

To tell the truth, I had only set up the umbrella to create a larger gobo in case the photographer shifted camera positions while I was busy

doing other things. He thought I did it for him, though. Only after setting it up did I realize that I could shade him as well. But what he didn't know wouldn't hurt him, and it did me quite a bit of good. This photographer has hired me for many jobs over the years.

I stumbled onto a simple, but profound fact. Small distractions can interfere greatly with the photographer's process of making a photograph. By eliminating anything that takes the photographer's attention away from the shot, be it a phone call or physical discomfort, I can help make a better photograph. Because I saw the many levels involved in making a successful shoot, I got hired ahead of other, perhaps more technically proficient, assistants who couldn't see the "big picture."

Though your first responsibility is to the photographer and the shot, don't forget about the photographer's client. If clients are present on a shoot, you should extend your services to include them as well. Most photographers want their clients to be treated well and made to feel pampered, to put their studio in the best light. To paraphrase one photographer, "If I get jobs because I have chocolate croissants at my studio, get the client a chocolate croissant." By extending your hospitality to the clients you make them feel welcome and happy to be working with your photographer. This may translate into more assignments for which the photographer can hire you.

After spending four years in photography school and thousands of dollars in tuition, this may all come as a shock and be a bit humbling. While working as assistants you will have to perform many tasks that you erroneously think are beneath you, but it's just part of your job. You are there to help the photographer in any way that you can to get the shot, and sometimes that includes doing a little fetch and carry. I'm not saying that you have to be happy with getting someone a cup of coffee, but that the more you offer photographers in terms of improving their business, on all levels, the more likely they are to fulfill their role in your relationship.

Roles

The other half of this relationship is the role played by the photographer. Photographers have a responsibility to accept their roles as teachers as well as image-makers. They must realize that the assistant is not just there for a paycheck, but to learn what it takes to become a photographer. It would be naïve to say that there aren't a large number of photographers who see assistants merely as hired hands and who don't take an active role in helping them progress as fellow professionals. But the vast majority know that by passing on their wisdom to their assistants, they get assistants who are more motivated to help their studios flourish.

In a way, it's very much like an apprentice/craftsperson relationship: for a job well done the photographer imparts the knowledge and experience that the assistant will need to one day become a photographer. How much of that information and advice is passed along depends heavily on the assistant's value to the photographer. Lazy or untrustworthy assistants will not receive much support from the people for whom they work. On the other hand, photographers who mistreat their assistants should expect less dedication from them.

Now let's face some facts of life here for a minute. The photographer doesn't owe you anything more than what is the standard practice in your area. In New York City the deal, for a full day's work, is that the

assistant gets lunch and a paycheck at the end of the day, or at the end of the shoot when working more than one day. Nothing more. The assistant should perform the job in a professional manner suitable to the photographer's needs, which may include working on the set, simply running errands, or cleaning the studio. This is the minimum you are required to do for each other, but if that is all you're both getting out of it, I suggest you find some other photographers to hire you.

Respect

Respect between photographer and assistant is more important than you might think. There are many people out there who do not respect their assistants. This is in part because of past experiences with poorly trained and unmotivated assistants who have left bad tastes in their mouths. With every photographer for whom you work, you will have to build up a reputation as a good assistant to get the respect that you deserve. Much of what you do is critical to a shoot, so you can't really blame them for being nervous. They won't automatically trust that you know what you're doing and may hover over you, watching your every move and looking for errors. But in time they should relax and even rely on your skills and judgement. By relying upon you to do your work without supervision, they are exhibiting their respect for you as a professional.

Some photographers will never respect their assistants. They see them as drudges to fetch and carry. Most often this is a personality flaw that locks them into a vicious circle of hiring one bad assistant after another. These people never catch on that they get bad assistants because they treat them all like dirt. The good ones won't work for them.

I once worked for one of these photographers. She was a big-name celebrity photographer and I was seduced by the thought of meeting rock-and-roll and movie stars and traveling all over the country. Failing to heed the warnings of other assistants who had either worked with her in the past or had heard of her reputation with assistants, I leapt at the chance to work for her. Boy, was that a mistake.

Now, I pride myself on being able to work with anyone. I'm a very easygoing guy and realize that photographers can get bent out of shape over the smallest mishaps in the heat of a shoot, but I was totally unprepared for the abuse that I was to suffer at her hands. She bellowed at me in the most offensive language she could muster, continually blaming me for things that were beyond my control as a freelance assistant, such as poor maintenance of her strobe and camera equipment. Her 35mm camera literally sprang apart in my hands, and somehow that was, in her mind, my fault. Later I was to find out that the same thing had happened to another assistant several weeks earlier, and the photographer had never had the camera repaired.

She leveled accusations of incompetence, ingratitude, and sloth at me, but I gritted my teeth and stayed silent. Someone had to make a show of some professionalism, and it looked like it was going to have to be me. After three days of this abuse and a feeling in my stomach like the beginnings of an ulcer, I collected my check and prepared to leave for good. On my way out the door she pulled me aside and told me that she thought that we worked really well together and would like me to stay on full-time. Stifling a laugh I walked out without a word. I bet she's still wondering why she can't get good assistants to stay for very long.

Sometimes photographers will feel the need to dress you down in front of the client to cover an error on their part. That doesn't bother me; I know why they are doing it and know that it's not directed at me personally. After the client has gone they apologize and thank me for helping them cover the mistake. Hey, I'm there to get the job done and do whatever it takes to make the photographer look good.

Communication

When the assistant/photographer relationship is working the way it should, the photographer sees the assistant as a valuable asset to the business and responds in kind, making time available to answer questions and to aid in the assistant's development as an assistant and a photographer. The assistant should feel comfortable asking the photographer questions about most aspects of the business. In return, the photographer should be assured that the assistant would keep any sensitive or proprietary information confidential. So learn to keep your big mouth shut. This is a small world, and word that you are talking about photographers behind their backs has a way of coming back to haunt you.

Good communication is vital between photographers and assistants, but it is often up to the assistants alone to make adjustments to their way of doing things to make this possible. What is as clear as a bell to the assistant may make no sense to the photographer. Be ready to alter the simplest of acts to the method preferred by the photographer.

Each photographer is a little bit different from the next, handles situations in his or her own way, and speaks his or her own language; so it's up to you to become your own interpreter for each and every photographer for whom you work. After you have assisted a photographer a few times you will begin to understand intuitively what is wanted or meant in certain circumstances. By watching and listening to a photographer at work you should be able to pick up on any individual quirks. This may be an order in which things are to be done, or a unique way in which the lights are to be set up. An assistant who can quickly adapt to a photographer's way of doing things is very valuable.

Photographers, being visual people, are not always great verbal communicators. Often a request for a piece of equipment is no more than a vague hand gesture and a mumbled, "Get me the thingy." I call this *photo-speak*. All photographers have shorthand names for items around their studios, usually because they can't remember what they are really called. Because every photographer is a little different, what may be a "thingy" for one is a "whatchamacallit" for another. Some photographers can get even trickier and change the nickname at random. Pay attention to what's going on around you and on set and you may be able to make educated guesses at what the babbling photographer is talking about.

Another aspect of good communication is the proper way to tell the photographer about a problem on set. Ideally, a shoot should appear flawless to the client, but we all know that problems happen: a strobe may misfire, the aperture setting may get knocked out of position, or some other mishap may occur. Barring a fiery explosion of a strobe head or other obvious disaster, any problems should be brought to the immediate attention of the photographer, quietly. Try to inform the photographer of the problem in a low voice so only she can hear you if there is a client present. Another good idea is to place your body between the

photographer and the client to mask any visible reaction from the photographer. The photographer then has the option of directing you on how to make any corrections without the client catching on. Observant photographers will notice and appreciate your looking out for their reputation.

The Client

Communication between the assistant and the client on a shoot is a touchy subject for most photographers. Assistants should take great care every time they interact with the client because everything they say or do reflects upon the photographer. Though assistants must be friendly and hospitable to the client, their first responsibility is to the person who signs the paycheck, the photographer.

The best way to tackle this subject is to just lay down some ground rules. First, there is much that the photographer doesn't want you to tell the clients. Don't volunteer any information about the photographer or the shoot. The photographer may have reasons not to tell them certain things. Being tight-lipped can be tricky if the clients come right out and ask specific questions, because you shouldn't appear as if you are anything less than open and accommodating. If they ask you for information that you know the photographer would not want broadcast, use delaying tactics: tell them you're not sure and will check on that for them and hope they forget about it.

Second, always show the photographer any Polaroids before you show them to the clients. The photographer is using the Polaroid film to help form the final image and might not want the clients to see it until the shot is ready. In some cases, the clients have no idea what they're looking at, but will start making ludicrous suggestions based on what is visible in the Polaroid—guaranteeing the photographer a headache by the end of the day. Show the Polaroid only after the photographer's okay.

Lastly, and most importantly, don't ever get between a photographer and his client. It's like a dog and its bone; you will get bitten. The photographer may feel that the relationship with the client is threatened if you get too chummy. Even if you work regularly with the same person, maintain a professional distance to keep the photographer feeling secure.

The biggest no-no in assisting is soliciting work from a photographer's client. Despite this, I have seen assistants solicit work from clients right there in their boss's studio. There's no quicker way to get your butt tossed out of a studio than to hit up a photographer's client for work. It won't end there, either. Word spreads quickly about pulling that stunt, and the assistant dumb enough to do it will find it very hard to get another gig. If a situation arises with a client and you are unsure of how to handle it or what to say, check with your photographers. Follow their lead.

Problem Resolution

Into every life a little rain must fall. How you deal with the inevitable disagreements and problems that arise between you and your photographers will directly affect the assistant/photographer relationship, for better or worse. Miscommunication and money are the two most common sources of difficulties. No matter how hard you try to get on a pho-

tographer's wavelength, there will be times when the photographer has one thing in mind but says another, causing costly mistakes for which you don't feel you should be blamed. Disagreements over a photographer's less than timely payment of invoices can also stretch your patience to the breaking point.

Miscommunication

At times, instructions given by the photographer may be garbled or difficult to understand. The photographer may even be at fault for giving me the wrong information, but whatever the cause, I don't press the blame. It wouldn't do me any good to be right at the photographer's expense. I don't like to be told that I'm wrong about something, especially when I'm right. In any other circumstance I would fight tooth-and-nail to prove that I am right, but on the job it doesn't really matter who's right or wrong because the job still has to get done. Many times I have redone work to satisfy the photographer even though my way was better. It's frustrating to always be on the losing end of a disagreement, but I just remind myself it's not my shoot. When it's my shoot, the assistant will do it my way.

Money

Money is probably the largest cause of strife in this business. For most people it is a difficult subject to bring up, but dealing with some matters up front can help you avoid nasty complications later on. At some point in his or her career, every assistant will have trouble getting money from a photographer. It should be expected. The photographer, we hope, is simply slow in paying because of a temporary cash-flow problem, but there are those out there who routinely take advantage of freelance assistants by delaying payment as long as they can. Some photographers even try to stiff their assistants.

As I mentioned earlier, the proper time to discuss payment arrangements with photographers, if you haven't previously, is when they book you for the first job. Remind them of your day-rate, or accept their offer, and ask them when they pay. Some photographers have payroll companies who cut their checks twice a month, so two weeks is the most you should have to wait for payment. Otherwise, it is the industry standard to walk out of the studio with a check at the end of the day. The problems start when photographers deviate from these procedures.

Acceptable Delays

As a freelance assistant, you basically live hand-to-mouth and can ill afford the delay of a single paycheck. Occasionally, though, you may have to make allowances for the cash-flow crunches experienced by your regular customers and give them some extra time to pay. It's just good business. But you still have to protect your own business at the same time. It costs a lot of work-hours to chase photographers down for a check, even if they are on the level, so make arrangements agreeable to both sides on what to do in the event of delayed payment. It's better to get this out of the way before it becomes a problem. The best of friends can become bitter enemies when money comes between them.

When a photographer with whom I've worked before asks me to wait for payment, I make the following arrangement. At the end of the job I get a check dated for that day, but I will hold on to it for an agreed amount of time before depositing it. At the end of that time period, I

promise to call to confirm that it is okay to deposit the check. This method saves me the time of calling and trying to get the check, because I already have it in my hand. It's a sign of good faith on the photographer's part to have the money available to me by the arranged day. The photographer in turn learns to trust me by my professional way of handling the situation.

Scams

Unlike honest photographers who have temporary cash problems, there are some unscrupulous photographers out there who will try to play you for a chump. They are unconcerned that their money games detrimentally affect the fragile assistant/photographer relationship, and they pull all sorts of tricks to delay giving you your money—so be ready for them. I've had to learn the hard way what these games are and how to combat them. The best way to prevent some of the following scams from being run on you is to discuss with photographers your requirements for the payment of invoices when they book you for the job. Speak in a professional, polite tone, but be insistent.

One game out-of-town photographers play is claiming that they've run out of checks and will have to mail it to you later. It's always possible that they really did run out of checks, but if you let them leave without paying, you will spend a fortune on long-distance phone calls nagging at them to pay up and you'll be lucky if they pay you at all. Once they are back home, you can't just show up on their doorstep to get your money. Don't be afraid to put your foot down on this one. It's unlikely you will ever have to work with them again, so you don't have to protect a long-term relationship with them.

The last time a visiting photographer tried this one on me, I stopped work and reminded him that he was informed that he had to pay me before he left. I told him that he would have to find an ATM and pay me in cash or he wasn't going to leave New York with any of his equipment or film. Lo and behold, he found one last check in his briefcase. It wasn't very diplomatic of me to threaten what I did, but I wasn't going to waste my time tracking him down for my money.

Another game unethical photographers play is asking you to wait until they get paid before you get paid. No way. Never allow this one. Photographers may have to wait up to 120 days for an advertising client to pay them, and even after they get their money you will probably be far down on the list to be paid. There is no reason you should have to take on some of their debt. Photographers who ask you to wait for a check are counting on you to meekly submit so that they can hold on to your money until you become too much of a pest to make it worth their while to hold it any longer.

A photographer whom I had known for years once suckered me into waiting for payment until the client paid him. Because I wanted to appear understanding of his financial plight, I accepted. Big mistake. After seventy-five days and numerous phone calls trying to appeal to his sense of fair play, he stopped answering my phone calls. Finally, I had to relay a message through his studio mate that I was coming down to the studio and not leaving until I got my check. When I arrived, there was a check waiting for me.

Other photographers are habitually slow payers. They give every excuse under the sun to delay paying your invoice, like they're waiting for a check to clear, or the payroll service goofed and it will be paid in the next cycle—anything to avoid handing you a check. It's a sign that they do not value your relationship. You will have to decide if it's

worth working for these people enough to continually wait for your money.

I intensely dislike confronting a photographer over money, but sometimes it is necessary to get a deadbeat to pay up. After getting the runaround for over ninety days once, I had to storm into the studio and cause a scene before I got a check. The photographer had stopped taking my phone calls, so I was left with few other options. Knowing he had a shoot going on and a client present, I walked in and started shouting loudly in the front office that I wanted my money and threatened legal action if I didn't get it immediately. Because his client was there, the photographer cut the check quickly just to shut me up and get me away from the client. Of course, doing this guaranteed that the photographer would never hire me again, but after getting brushed off for ninety days I didn't want to see the guy ever again.

This last solution, as well as taking legal action, is a drastic, final step directed at nothing more than collecting the money you are owed. When the situation has come to this point, the photographer is telling you that there is no assistant/photographer relationship between you, so take off the gloves and get what you're owed.

Assistant's Burnout

There exists one last common problem that can strain even the best assistant/photographer relationship, and that is "assistant's burnout." At least once, if not several times, in a career all assistants will get fed up with being an assistant. They won't be able to stand the thought of getting another cup of coffee or setting up someone else's lights. This may happen for any number of reasons and to varying degrees, but its detrimental effect upon the quality of an assistant's work can injure his or her reputation.

Since most people use assisting as a stepping stone to becoming photographers, even the best assistants get frustrated at times by a lack of progress towards that goal. Some assistants get edgy and discontented when they discover that they are not learning anything new from their photographers and are doing the same old thing day after day. Some become disheartened after a time because they are still only assistants. They believe they should have progressed to being a photographer already.

When assistants feel like this the quality of their work declines. They watch the clock, looking forward only to collecting their check and getting the hell out of there. Impressing their photographers becomes unthinkable, and even top-notch assistants only make the minimum effort to get the job done. Some assistants even start to snap at their photographers. As time goes by this decline in morale worsens. This is "assistant's burnout." I should know; I've been burnt out at least four times during my career.

All of these are actually good feelings. Something inside is telling assistants that they need to learn more or move on to a place where they can get more of what they need to advance towards that goal of becoming a photographer. Burnout is what will eventually force assistants to shed the security blanket of working as assistants and strike out on their own as photographers.

The trouble lies in the effects of burnout upon an assistant's relationship with the photographer. Even the most understanding of photographers gets put off seeing an assistant no longer working hard. If the assistant fails to change this decline in the quality of work, the

photographer has little choice but to start looking elsewhere for more motivated help. All sorts of bad feelings begin, on both sides, when that happens.

To avoid crashing and burning like this, take some time off when you feel like you are getting burned out. If you need to keep working for your current list of photographers, tell them that you are burning out and need some time off to get back to your old self. If you want to move on to other photographers to add some variety and are able to do so, do it. Just don't burn any bridges behind you. You never know when your relationship with a photographer may come in handy.

When I burned out the first time, I did everything I could, unconsciously, to shoot myself in the foot. I spent my days watching the clock and bolted the second the photographer released me in the evening. No longer servicing my photographer properly, I became lazy and sloppy in my work. Frustrated at my lack of progress as a photographer, I was completely unaware that I had turned into an unpleasant person to be around.

Luckily, the photographer for whom I had been assisting regularly for over a year knew more about "assistant's burnout" than I did. He knew that I was a good assistant, but that I needed a change of scenery, so he fired me. He told me that it was just time for me to move on, but that he would be available if I ever needed advice. Though I knew then that I had left him no other choice but to hire another assistant, I was furious with him for a while. I needed the money.

Only later did I realize what a rut I had been in and that it was a good thing that the photographer had fired me. I moved on to working with other photographers who challenged me, and learned more about photography than I would have working for just that one photographer. Because that photographer and I had ended our working relationship on good terms, we remained in contact, and he has been a constant source of advice over the years. After some time, I even resumed assisting him on occasion. Strangely enough, now he is my biggest client— eight years after firing me.

Good Relationships

The concept of "clicking" with a photographer cannot be discounted. Despite being the most technically proficient assistant in town, able to communicate well, service clients, and handle any problems with ease, sometimes an assistant's relationship with a photographer never really gets off the ground level. Basic personality conflicts can hinder the formation of this bond. Photographers tend to enjoy the company of assistants with similar personal interests and temperaments. Excessively good-humored assistants rarely mesh with dour or ill-tempered shooters, and vice versa. That is not to say they won't work well together, but that they will usually lack that personal connection that elevates their relationship beyond the worker/boss level. So assistants would be wise to search for photographers with whom they have something in common apart from photography.

I've been fortunate to have good long-term relationships with three photographers. Aside from providing me with a steady source of income, they have been instrumental in my growth as an assistant and a photographer. They have helped me immeasurably with both creative and technical advice over the years and have always been supportive in

times of need. Through them I have made valuable connections in this business that would not have been available to me otherwise, and I am eternally grateful for all they have done for me.

One in particular has been something of a mentor to me. Over the years he has taught me much of what I needed to know about the business of photography. Always forthcoming with information, he's shown me the ins and outs of running a business in general and how to steer clear of many of the pitfalls that plague fledgling photography businesses. He has advised me creatively and technically and has shared his industry contacts with me. His head will undoubtedly swell upon reading this, but aside from being a great photographer, he is my mentor, my confidant, and my friend.

I first saw Gary Gladstone's work at a seminar given for assistants by APA. The next week I noticed a classified ad he had placed in *Photo District News* for a new assistant. Leaping at the opportunity, I scheduled an appointment with him for an interview. We hit it off immediately. Everything just clicked. With a good referral about me from a photographer friend of his (coincidentally, the guy who had fired me as his first assistant several weeks earlier due to assistant's burnout), Gary decided to try me out.

During the first few jobs we found that we worked on the same wavelength. I understood what he was going for creatively with his photographs and did my best to help him get it. I intuitively worked the way he wanted his assistants to function. He saw me as a valuable asset to his business and treated me that way. In return for that respect I gave my all.

Over the next few years we developed into a team and worked together like a well-oiled machine, each knowing what to expect from the other. In exchange for my good work and dedication, Gary taught me anything that I wanted to know from him about the business. He has critiqued my photography at my request and helped me develop several portfolios. He has even passed a few shoot jobs my way and continues to do so.

When "burnout" crept up on me again, I moved on to explore other avenues and to protect the relationship. Though I no longer assist Gary on a regular basis, we speak often. Since he is active in the photographic community our paths cross quite a bit. Gary hires me to guest lecture with him at seminars on his work, and we have served together on the APNY board of representatives. Recently, he honored me by including an interview with me about assisting in his latest book, *Corporate and Location Photography*. Though we rarely work together nowadays on assignment work, Gary hires me to assist him on personal projects that take us all over the country.

In the last three years we have driven over twenty thousand miles together while working on his latest project. Being in the car together for that long can put a strain on any relationship. I don't think most *marriages* would survive being cooped up that long, but somehow we manage not to kill each other.

It has been on these trips that I started shooting the work that is the core of my new portfolio. Gary allows me time to shoot my own images on these trips, and I was surprised to find that I truly love making them. This latest portfolio has gotten me quite a bit of attention and compliments from photographers and art buyers alike. Through one of my other photographers, because of this new portfolio, I now have a photographer's representative, Michael Pape.

I hope you have found in this chapter a sense of how it all fits together. The associations that we forge with our photographers directly affect

our careers as assistants and, if we're lucky, continue on through our emergence as photographers. Knowing how to avoid the pitfalls of assisting so that you can foster the good relationships is crucial to success. Although our goal is to eventually become photographers, how we spend our time as assistants can make achieving this goal that much easier.

5

Shaping Your Career

Assisting is like driving a car: knowing where you're going makes it a lot easier to get there. It took me a couple of years to figure that out for myself. Being a guy, I'm prone to just heading out without a map and refusing to ask directions, but in doing it that way I took many wrong turns. Although those detours took me to some great places, the trip would have gone faster and more smoothly had I planned my route.

I have been incredibly lucky. Not knowing what kind of photography I wanted to do, I chose to try a little of everything by assisting as many different photographers as I could and to take my time doing it. Many of the opportunities that have come my way were due to pure luck, to being the right person in the right place at the right time. All of my goals were short-term: to work for this photographer because I liked his lighting style, to work for that one to do a little traveling. I didn't set any one course for my career, and as a result I wandered aimlessly for a long time. Now, you can do what I did and just blunder around and trust it all to fate, or you can take a more sensible path and make plans to shape your career.

Setting Goals

The assistants who are aware of what they want to get out of assisting, and know why they want it, have a leg up on the others. By setting some simple, clear goals for themselves, they can progress along the road that will get them what they want, faster. Having these goals, they can determine what information or training they will need to achieve each one.

Not everything goes according to plan, though, and the best laid plans can go awry for any number of reasons. In fact, the plans themselves may become useless if the goals change. Outside factors have a way of upsetting them as well; not every contingency can be anticipated. Life is full of surprises, so a wise assistant stays flexible in executing any plan.

Becoming a photographer is the first goal for you to set for yourself. It's a straightforward, overall goal. Deciding what type of photography you want to shoot professionally may prove to be a bit harder. In New York City, where I work, photographers usually specialize in one particular area of photography, like still life, portrait, or fashion. Photographers in smaller markets tend to be less specific and shoot a variety of assignments, but here in New York there are so many photographers that the art buyers like to pigeonhole them into narrowly defined categories. So pick one. If you are undecided about which specialty to pick, choose the ones that interest you the most and make them

 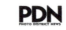

your goal. Don't be afraid to make a choice; you can always change your mind later and alter your plans.

There are also some "lesser" goals that you can set for yourself that will aid in achieving that overall goal. One of these goals is to become a good assistant. Assistants who are not just technically proficient but also work well with their photographers are afforded greater access to the tools and information that they will need to make that transition to photographer. Any assistant who has waded through this book up to this point, I think, has proven that the motivation to improve as an assistant is there.

Many assistants set their sights on working for a big-name photographer. Although I have never worked for anyone whose name is mentioned in whispered reverence, I can't fault any assistant for wanting to work with the best. These photographers are at the top of the heap for a reason, and assisting for them is an opportunity to see what goes on in their heads. There is also a unique status that goes along with assisting for one of these industry leaders that can do an assistant a lot of good.

Some people will tell you that you should set a goal for how long you will assist. Photographers are full of stories about how they only assisted for a year or two before they opened their first studio. Of course they did; that was twenty years ago. Times are different now. The market is glutted with photographers, and it is a lot harder to break in these days.

I don't buy into setting a deadline for yourself on how long you will assist. Everyone works at his or her own pace, and if it takes someone twenty years of assisting, then that's how long it takes for that person. If you can do it in one year, great! You will be an assistant for however long it takes you to put together a professional portfolio and book enough shooting work to earn a living. Even after you have that portfolio, it will take some time to build a steady enough client base to give up assisting permanently.

If it makes you feel better to put a time limit on something, set a goal to shoot something for yourself, say, once a week while you are assisting. Shoot as often as you can. It's hard sometimes as an assistant to find the time or the energy to shoot after a long day of working for a photographer, but it's the only way to hone your skills and create that great portfolio. A killer portfolio may not be critical as an assistant, but it is the key piece to getting assignments as a photographer, so shoot, shoot, shoot.

Making Plans

Now that you have settled on your goals, you have to develop a plan to meet them. Determine what steps you can take to arrive at your final destination, becoming a professional photographer. Plans are different for every person because each has unique needs. Some find that they need to study photography first at a school. Others leap right into assisting. Take whatever steps you feel are necessary for you to learn this business and refine your personal vision of photography.

A first step for many budding photographers is to enroll in an art or photography school. There are lots of schools out there that offer everything from intensive ten-month programs, like the Hallmark Institute in Massachusetts, to four-year colleges that offer bachelor's degrees in photography, like my alma mater, The School of Visual Arts. Each school has its own way of teaching photography. Some stress the technical aspects of photography, while others focus more on the aesthetics.

Do a little research and find out which one is right for you. Interview each school to find out what classes they offer, who the instructors are, and what the facilities—studios and darkrooms—are like. I settled on SVA because of a recommendation from my high school art teacher, Herman Freeman. Location was a big consideration for me as well. I wanted to work in New York City, so SVA fit the bill.

Having very little technical expertise in photography and wanting a bachelor's degree to fall back on if photography didn't pan out, I felt a four-year school would be ideal for me. I had only the vaguest idea of what kind of photography I wanted to go into when I first started school. I just knew that I loved photography and wanted to become a photographer.

I thought that expert tutelage and the structure of classes would teach me all that I needed to know about how to shoot, and that I would walk out after four years and be a photographer. Talk about naïve. Though the school gave me a solid base from which to work, it was just the first step.

The next step for most is to assist. There are those rare wunderkinder who walk out of school and straight into shooting, but the rest of us need to make a living while we refine our photography to a professional level. This apprentice-like situation lets us pay the rent while we work closely with pros, learning what they know and using that information to get us closer to our goal of becoming photographers ourselves.

When assistants know exactly what information they want, they can target a specific photographer for whom they would like to work. Say, for example, that an assistant has seen a particular photographer's images, loves the lighting style, and would like to learn how it is done. By working for that photographer, this assistant will learn directly from the photographer how and why the lighting is done in that fashion. This assistant can then use that information to augment personal imagery.

Assistants who wish to shoot in one particular area of photography would be wise to work for some photographers who specialize in that field. More can be learned about shooting still life from a photographer who runs a still life studio than one who shoots fashion. There are tricks and standards in each field of photography that can be learned only from photographers who shoot those kinds of images day after day.

Many of the outside services that photographers use, such as set builders and stylists, also work solely in given fields. Hair and makeup stylists rarely work on still life sets, and you won't often find a food stylist, also known as a home economist, on a portrait shoot. These are people you will need to do your own shoots. While working as an assistant in their area of expertise you will be brought into contact with them. Get the promo cards or contact information of those with whom you would like to work on your own jobs. Stylists are usually on the lookout for new business and are more comfortable working with someone that they already know.

There is the danger here of assistants being too goal-oriented and working only for photographers who shoot the kind of photography that they intend to shoot professionally. Assistants should leave their options open. Even established photographers change their minds and switch specialties from time to time. Working exclusively in one field narrows an assistant's perspective on image-making and the industry itself.

I always suggest to rookies to try everything, particularly if they are unsure what they want to shoot themselves. Concentrate your efforts

on the areas that interest you, but give the others a fair shake. Who knows? You just might like them. Try assisting for all the specialties available in your home area. Apart from keeping things interesting, you just may learn something that you can use for your own work or as an assistant for someone else.

As I was exposed to each of the specialties my interests changed, but since I never laid out a specific plan for my career it didn't alter it much. Each new photographer provided me with an opportunity to learn something new, meet people, and take my photography in a new direction. What I liked, I incorporated into my own images. Doing this, of course, made my portfolio very erratic, and the multiple influences clashed until I progressed beyond emulating other photographers.

Working for varied types of photographers extends to assisting photographers of all experience levels as well. It's useful to gain as much perspective on the business as you can, so assist for beginning photographers as well as for the top dogs. There's something to be learned from all of them.

As I said before, assisting a big-name photographer, like Mary Ellen Mark or Jay Maisel, has its advantages. It's always smart to learn photography from the best photographers. Working for them will give you an invaluable insight into how they approach making such wonderful images and how they manage their businesses so successfully. Even if you haven't made it one of your goals to work for a photographer like this, I suggest strongly that you consider it.

With these photographers you will also learn how to produce high-end jobs. It's very different producing a $100,000 job than a $2,000 one. There may be three assistants, multiple stylists, and set builders involved in a big production that all have to be directed at the same time. Somehow they manage to keep track of it all and still make a great image. If you succeed in landing a gig with a photographer who shoots big-budget jobs, keep your eyes and ears open and store all of that information away for future reference.

There is also a certain cachet that goes along with being a big-name photographer's assistant. This industry is often run on a "who's who" basis. More doors are open to you with a "name" behind you. It doesn't necessarily follow that you are better than other assistants are or know more than they do, but name-dropping is almost a form of currency to many in this business.

Because certain labs and suppliers connect me with a well-known photographer who is a good customer to them, I enjoy a certain preferential treatment when dealing with them, even in the case of personal business. I'm greeted warmly and treated with respect; but in stores where this photographer is not known, I'm viewed as just another schnook off the street. Trading on my connections goes only so far.

It's obviously more exciting to work for a legendary photographer, but what works for a top-shelf photographer may not apply to a photographer in the first years of shooting. One thing top photographers often forget to teach their assistants is that they won't have the clout to do certain things until they make a name for themselves. It doesn't matter for which big shot a young shooter used to work; no client is going to spring for a first-class airline ticket for an unproven photographer. Different rules apply for rookie photographers than for the big guns.

That is why it's important for assistants to work for less well-known photographers too. By assisting photographers at the lower end of the spectrum, assistants will learn how to run their photography businesses when they are just out on their own. The big-name photographers

teach them the ideal ways to operate, but it's the average photographer who instructs them on the realities of survival as a rookie. The shoot jobs a less established photographer is likely to get require the ability to produce on a shoestring budget. Shooting with a small budget is best taught by photographers who do it all the time. It's a valuable lesson.

Take all of this into account when you are planning how to become the photographer that you want to be. You will probably need some form of training to refine your technical, aesthetic, and practical skills to a professional level, so make a well-defined strategy for yourself, listing what you need to do and where you think you can get the information that you will need. Write it all down on paper and stick it on the refrigerator door if it helps you to keep it straight. I'm a firm believer in writing little reminder notes to myself and leaving them all around the apartment—much to my wife's dismay.

Adapting What Works for You

With the confidence of knowing where you are going and roughly how to get there you can pay attention to what's going on around you. Keep you eyes open for anything that may help you on your way. There are many things that photographers use or do that you can adapt for your own purposes.

Assisting is a lot like shopping. Look around the photographer's studio for things that might be suitable for the way you work. It can be a piece of equipment, or a procedure, or a way of seeing an image that the photographer has. For a long time I was an impulse shopper; I included in my photography anything that tickled my fancy. Although emulating a photographer's style is one way that we learn to shoot, doing that has a way of suppressing your own vision for your photography. So, be a responsible shopper.

If you want to start photographers salivating, put a new piece of photo equipment into their hands; it's guaranteed to get a reaction. Photographers turn into big children when you show them a new toy. While browsing in camera shops I'm sure that I've heard more than one photographer whine, "I want it, I want it, I want it."

Assistants are the same way. We have the advantage over photographers in one respect, though. We get to use a variety of photo equipment—cameras, strobes, and meters—on a daily basis. Working with photographers is one long test drive for which we get paid. Using the photographer's equipment, we get to evaluate it in working situations before we fork over our hard-earned money for any of it. Actually using the equipment on shoots tells us more about its suitability to our needs than the few minutes we spend playing with it in the camera store.

Pay attention to what equipment is used by your photographers and why they own it. As you assist more and more, you will see that certain types of photographers use particular equipment. For example, still life shooters tend to use bigger, more powerful strobe units than a location photographer, who most often opts for smaller, lighter, less powerful strobes. Use your experiences as an assistant to choose the gear that is most suited to the way you shoot.

When I started photography school all I owned was one 35mm camera body, a couple of lenses, and a light meter. It was all I needed. The school provided large format cameras, strobes, and grip equipment.

As I began assisting and my needs for equipment changed, I paid close attention to what my photographers were using. The gear that

best suited my needs and was built well I bought on an "as needed" basis. Big-ticket items like strobes and cameras are a huge investment, and once photographers start with a system, they are likely to stay with it for a long time, so I weighed my options very carefully before I pried open my wallet.

I chose a strobe system that I had used frequently with my photographers and had determined would be right for me. Since I mostly shot people on location, I did not need enormous amounts of power, so I picked a unit that was compact and light to make hauling it around easier. Two power packs, three strobe heads, and a multitude of attachments later, I have not regretted my choice.

Cameras and lenses required more thought. After assisting a photographer who had his only camera body die on a shoot, I decided to add a second 35mm camera body to my list. I chose lenses on the basis of which ones I saw photographers use most often.

Finally, when it came time for me to invest in a medium format camera system, I opted for the Mamiya RZ67. What can I say, it's a *sweet* camera. I had extensive experience with it from assisting Mamiya owners, and I knew the reps from the manufacturer through some of my photographers and APA. It suited my needs in a camera to a tee.

Because most of us are equipment mavens and love to have a new "toy" with which to play, there is the danger of buying every little gadget that we see. Our fingers itch every time we walk into a photo store. If you *want* a toy, by all means get it, but try to buy only the gadgets that you have seen used and that you have judged are suitable to your needs. Save your money for the stuff you really will use.

Keep your eyes open for any special equipment used by your photographers. Photographers are very resourceful people. Some come up with the most ingenious uses for common objects that I have ever seen. These simple solutions can save you time and money.

One photographer for whom I assist attaches dog collars to his strobe packs. Since he works entirely on location, frequently in busy areas, he hangs the strobe pack by the dog collar from the light stand. That way he weights down the stand in case a passerby accidentally bumps it, keeping it upright and avoiding a costly repair. I also appreciate not lugging sandbags around everywhere we go.

Another marvelous piece of equipment is Velcro. I've witnessed photographers use it on everything. One photographer I know uses the adhesive-backed variety wrapped around his lens barrels to hold filter rings. Not a bad idea when you take into account the price companies charge for those things. Another photographer uses the same type of Velcro glued to the side of his strobe packs to hold radio slaves to protect them from getting kicked around. Velcro straps are also handy to tie up extension cords for tidy storage.

While you are ogling the gear, keep track of how the photographers do other things. They have learned, often by trial-and-error, how to handle troublesome clients and the deluge of paperwork that are involved in running a studio. If you can pick up any of their good habits it will save you some grief as a photographer. Some of these procedures can also be used while you are an assistant with your other photographers.

Dealing with troublesome clients is tricky. Each photographer handles them in a different way. However it is done, the photographer usually wants to appear to be taking "the high road" without getting pushed around too much. Watch and listen to how the photographer works through a tough situation, and try it for yourself should the need arise.

At some point, if the client becomes too much of a problem, a smart photographer will back away from the deal. When my first nightmare client attacked, I just tried to grin and bear it and work through the difficulty. I didn't want to lose the money that this client could bring in. To make a long story short, she fired me halfway through a multi-day shoot. She skipped out without paying me several hundred dollars and then threatened to sue me for withholding the film that I had shot on the previous day until I got the money.

Luckily I was stuck in an airport with my mentor, Gary Gladstone, at the time the threats started flying. He got me some expert legal advice and the client and I settled our differences.

There were signs, early on, that this client was nuts, but I had missed them. I just wanted that job so badly that I ignored the little warning buzzer in my head. Later on, I discovered that a friend of mine had been offered a shoot by this client, but had passed on it after their first meeting. She picked up on the client's wackiness and felt it was wise not to get involved. Okay, she was smarter than I was; but I learned my lesson. Heading off problems is better than mopping up the mess afterward.

Other bits and pieces that you can learn from photographers involve the endless paperwork that inundates a studio. If the photographer allows it, peruse some invoices and estimates for shoot jobs. Learn the language used and how the figures are laid out. Good invoices are specific and easy to read. Some of the photography groups, like APNY, have standard forms that you can use for your invoicing. Integrate the ones that you like into your own practices.

Photographers use many different types of release forms for different purposes: some are model releases, and others are location releases. Models or owners of private property have to sign these so that the photographer can use the images made of these subjects for whatever reason. Each photographer has a slightly different wording on the releases, but they all generally mean the same thing. I won't get into the legal issues of how they are worded or why, but find ones that work the best for you.

One bit of paperwork that is often overlooked and treated in a casual manner is the film notes page, or *data sheet*; a sample is shown in Figure 5–1. Film notes need to be kept in a clear, orderly fashion, so the photographer can process the shot film correctly and keep track of what was done for each image. Some photographers keep the most abominable notes or have poorly laid out forms, which may be clear to them but are totally incomprehensible to anyone else. Make one for yourself that can be readily understood by everyone.

I liberated this design from one of my photographers and have since introduced it into at least a dozen different studios. When I feel a photographer would benefit from a better data sheet, I print out this page from my computer with the photographer's name printed on the top. Photographers get a big kick out of seeing their name on the forms that I created for them. Whether or not they felt that they needed a new layout, they appreciate the effort that I make for them, and most see it as a clearer design than the one that they had been using. I also use it for my own shoots.

So many tricks-of-the-trade go flying by an assistant that it's hard to remember them all. An assistant would be wise to carry a little notebook around to write down each before it is forgotten. This book provides many of them, but there are always more being invented.

matt proulx
PHOTOGRAPHY
DATA SHEET

Job #: _9901_ Client: _ACME, INC._ Product: _PHONE CARD_

Date: _5/24_ Film Type: _E100S_ Film Total: _12_ Pol. Total: _HH_

Assistants: _STEPHANIE_

Test Roll	Roll	1st Run	2nd Run	Exp.	Description/Changes
T₁ (1-3)	1	N		f/8 1/125	MAN ON PHONE w/CARD SOFT FILTER
	2		+ 1/4	↓	↓
(4,6)	3	N		↓	△ ⚡
(7-10)	4		+ 1/4	↓	#1-5 PHONE / #6-10 NO PHONE
T₂ (1-3)	5		+ 1/2	f/11 1/125	△ WARDROBE + SET NO PHONE OR CARD
	6	N		↓	↓
	7		+ 1/2	↓	#1-5 ↓ / #6-10 ADD PHONE
(4-7)	8	N		f8.5	↓
	9		+ 1/2		↓
	10	N			★ GOOD ROLL ↓
(8-10)	11		+ 1/2		△ LOW ⚡
	12	N		↓	↓

Figure 5–1 As you can see, there is not much room in the Description column for notes, so use a legible shorthand. Use the symbol ⚡ to represent "camera angle," the symbol △ for "change," and use ↓ instead of ditto marks—dittos get mistaken for the number 11. List test frames on the line where they were shot.

One trick that I learned by assisting is to use the different film types to my advantage. The drabbest science laboratory can be made to look high-tech by using tungsten film. Under light sources other than tungsten, such as daylight or fluorescent, Type-B film goes a lovely blue. By putting a Full CTO gel on only the strobe lighting my subject (typically a technician of some sort), the subject appears a neutral color, while the background turns this blue color. This trick has saved me numerous times already.

Another trick that I learned from one of my photographers is to sync the camera to the strobe farthest away, usually by means of a radio transmitter. When using a strobe that can't easily be monitored to confirm that it is firing with all of the others, I hook up a radio slave to this pack alone. If the other strobes fire when the camera does, I *know* that the hidden strobe is firing. This is not necessary if all of the strobes are easily seen, but it is a useful trick when needed.

Not only does an assistant learn tricks and procedures from the photographers for whom they work, but also the creative processes that go into making an image. An observant assistant picks up on how the photographer goes about creating a photograph, what thoughts are behind it, and what stylistic touches are added to make it better. There are advantages and disadvantages to adapting parts of another photographer's style to your own work. To some extent it is unavoidable. Working closely with a photographer day after day, an assistant becomes susceptible to the influences of that shooter. Both consciously and unconsciously an assistant absorbs elements of the photographer's way of seeing images.

Though you want an image to be uniquely your own, an advantage to emulating another photographer's style is that you know it works. In some cases it is necessary to get the job done. I think I can *do* Gary Gladstone almost as well as he can. Gary is an expert problem-solver, and I have learned much from him over the years. Giving a chunky executive just the right pose to make him actually look trim and athletic is a specialty of Gary's that I use myself.

Unfortunately, emulating a photographer's style too closely can blow up in your face. Once someone else's style is in your head it's hard to get it out of there. Soon you find that you are merely a cheap imitation of the original. It is the original photographers with their own unique "voice" who get the good jobs.

I think that the most painful critique of my portfolio that I ever heard was from a designer whom I had known for years. After very politely reviewing my work he said, "I can see you know how to do Gary Gladstone, but what about your work? Show me something that says something about how *you* see things."

I was devastated. They were all very good images, but the designer was right; my work did look like Gary's. I had spent so much time learning to anticipate Gary as his assistant that I unconsciously had begun to shoot like him. I think I quit working for him the next day and spent the next year flushing out of my head all of the photographers for whom I had worked.

Influences are not bad things, but they shouldn't overwhelm your own style. Developing your own style is probably the most difficult and frustrating endeavor you will encounter as a young photographer, but it will come eventually, most likely when you least expect it. For me, I discovered that I had a style of my own when I stopped *trying* to develop one.

Contacts and Opportunities

You can't plan for opportunities. Situations can be molded to allow them to happen more easily, but some things have to be left up to chance. By being a great assistant you can put yourself in a position to be in the right place at the right time to take advantage of any opportunities—if and when they present themselves. Making as many good contacts as you can in this business is a very smart way to create those situations.

The first contacts you should make are with other assistants. They are valuable sources of information and possible links to getting more and better jobs. By associating with your fellow assistants you can learn from them any helpful information about assisting that they have that might aid you in improving your own assisting skills. Compare notes.

Knowing skilled, responsible assistants whom you can refer to photographers is a valuable asset. Aside from gaining a photographer's trust by supplying competent coworkers, you create an unofficial reciprocal arrangement with the other assistants. The next time they know of an assisting gig, they are more likely to refer an assistant who has gotten them work in the past. By cultivating your contacts with them, you make opportunities for more assisting work possible.

Being the kind of assistant that photographers want to hire also places you in a position to invite opportunity. When you have proven yourself a good assistant to photographers, there is a chance they will refer you to others. With each photographer you work for, your list of contacts grows to include stylists, suppliers, and reps, all of whom may come in handy in the future. Eventually, you will come across contacts that benefit you more than just by getting you further assisting jobs.

Some photographers have close connections with equipment companies. They lecture at company-sponsored workshops and even test equipment for them. Your ties with these photographers may bring you to the attention of these suppliers. This situation may create more opportunities for you. It did for me.

I assist for a few of the photographers who happen to do promotions for Mamiya cameras and equipment. Through those photographers I have gotten to know several of the people at Mamiya, and they have been very generous over the years in sponsoring my assisting workshops. They also honored me in Mamiya's Today's Assistants—Tomorrow's Pros program. I am immensely proud of this particular award, but I don't think they would have known me from Adam without my connections to their photographers.

Being connected with a particular photographer can bring great advantages, but it can also work the other way around. In some circles certain photographers are thoroughly disliked for one reason or another. Assistants who work for these photographers soon learn not to broadcast their connections with these people.

In my early days as an assistant, I remember working for one photographer who owed money all over town. Because he owed so much on his credit accounts, he had to send me with cash to stores to buy supplies—under the strictest orders not to reveal for whom I was shopping. I don't know what he thought the suppliers were going to do, but I think he expected them to confiscate the cash to pay his bills. Once or twice I let it slip that I was there for him, and I had to endure embarrassing harangues by the storeowner about unpaid bills. After that I learned to keep my mouth shut about working for him, but as long as he paid *me* I didn't worry about it too much.

Valuable connections may also come through trade groups like ASMP or PPA (Professional Photographers of America). As I said earlier in Chapter 2, the meetings they host and the workshops they give are full of photographers, all of whom are potential clients or contacts. Guest speakers are also possible resources that you can use to your advantage. I consulted with a big-name rep several times for free, because of my place on the board of representatives of APNY for which he lectured frequently. His advice was priceless.

Another rep, to whom I had access because of assisting one of her photographers, was Elyse Weissberg. I have consulted with her many times over the years, and she has been instrumental in my development as a photographer. It was she who first saw my breakthrough with my new work. If it hadn't been for her advice to make this work my new portfolio, it would probably still be nothing more than a bunch of contact sheets filed away somewhere.

More direct opportunities come from working as an associate photographer with an established shooter. Sometimes a client approaches a photographer with a job that is too small to warrant interest, but rather than turn the client away, the photographer farms the job out to a rookie photographer or a senior assistant for a percentage of the fee. This may even happen on a regular basis. It's a good way to get started as a photographer, and there is a chance that the rookie photographer's relationship with the client will continue beyond the associate agreement. I have one such relationship now with a client that started in this way.

There is a lot of information here to take in all at once, but I hope it gives you ideas on how to plan your careers as assistants. Set your goals, and then lay out a battle plan to guide you through the arduous task of achieving those goals. Along the way, keep your eyes open for the elements that you can incorporate into your practices and image-making to help them along. Finally, cultivate the contacts that you make throughout your career to create situations in which opportunities can be found.

6

Specialties

Although most photographers dabble in all areas of photography, they tend to center their efforts on the one that is their greatest strength. Art buyers and photo editors like to pigeonhole photographers into safe little boxes, so photographers often define themselves by their one strength. They are fashion photographers, or still-lifers, or portraitists, or whichever specialty in which they feel they work best. I think somewhere along the line an art buyer read a science book and decided it would be easier to categorize photographers by species.

Within each category are further subspecies. Every photographer has a different style, or way of shooting, and may even specialize as to the type of subjects photographed. One still life photographer for whom I work specializes in shooting electronic products. Another, a fashion photographer, because of her "Generation-X" style, shoots mainly hip-hop clothing. The variations are endless.

As a result of these innumerable permutations, my descriptions of each specialty are necessarily general in nature, but they will give you an idea of what goes on in each and what you can expect while assisting for photographers in these areas. Very little in assisting is set in stone. You might find that your photographers operate in different ways or with different equipment than those mentioned in this chapter, but being the good assistant that you are, you are adaptable.

Corporate/Industrial Photography

This is my area of greatest expertise as an assistant. I have worked for many corporate/industrial photographers over the years and have worked closely with one of the best for many years. Much of what I have learned assisting in this area is applicable to the other specialties, and I find now that several photographers in those other specialties hire me because of what I know from assisting corporate photographers.

This particular type of photography requires quick thinking. Very often corporate/industrial photographers have only sketchy information about the subject that they are to shoot, and must create a photograph "on-the-fly." The assistant has to be just as quick, not only in action, but also in decision-making. Time is a big consideration in this field.

Corporate/industrial photography is more diverse in nature than most other specialties. Requirements are skills in portraiture, still life, architectural, and illustration photography. It was just this diversity that first attracted me to this field. On any given day, you may be shooting a still life in the morning, an overall shot of a building in the afternoon, and then a portrait that evening.

This specialty is broken down into two basic parts, the corporate and the industrial. The corporate half is centered on executive portraits, while the industrial half is oriented around shooting the products and facilities of a company. I like to separate it into having to wearing a necktie for one, and being dressed comfortably for the other.

Corporate

Companies need photographs of their executives and corporate facilities for many reasons: annual reports, in-house newsletters, brochures, or sometimes for display. Most of the portraits assigned are of senior management, like the CEO or the president of the company. The corporate facility photographs can be anything from a tight shot of a display case or a computer to the whole newly designed atrium, usually to justify the expense to the shareholders.

When you are in these locations the companies prefer as little distraction as possible, particularly when shooting the CEO. As the assistant you are expected to "fit in." Unfortunately, that often means dressing in business attire. Personally, I hate wearing a jacket and tie, but it has its advantages in this stuffy world. In corporate offices everyone is identified as either "a suit" or as labor. It's easier to get what you need—a ladder, access to particular rooms, cooperation from other "suits"—when you look like you are one of them. It's a delicate

balance to act like them, but still be pushy enough to get your job done. Luckily they are "programmed" to obey a higher authority, so if you casually mention that the shot is of the CEO you can usually get what you need.

The portraits are of every variety. They can be of anyone in the company from a secretary on up to the CEO. Settings can be anything from environmental portraits, where whole rooms can be seen behind the subject, to tight head shots in front of a canvas backdrop. The people in them may just be smiling for the camera or posed to simulate working. As the assistant you rarely know what to expect. Even when one particular shot is planned, another may result due to last-minute schedule changes or sudden construction in the intended location.

Ninety-nine percent of a corporate photographer's work is done on location, so it is the assistant's responsibility, among other things, to get all of the photographer's gear to the site in one piece. Most corporate office buildings require that equipment be brought in through the loading dock. A resourceful assistant looks around for the flatbed carts that many buildings keep in these areas. Piling all of the gear onto one of these makes hauling it all through the building easier than dragging the multiple small luggage carts that location photographers use.

While entering the building the assistant should keep an eye peeled for anything that may be of use to the photographer, like possible locations or props. Though the photographer may have been given instructions to shoot in one place, a better location may present itself. An assistant who suggests good locations can score some points in this way.

The same goes for props. Very often a corporate photographer will need to add some items to a photograph to improve it or just to cover some unavoidable distractions. A ficus tree or other plants are very useful for hiding electrical outlets or strobe glare on dark wood paneling. Most offices have some greenery sitting around somewhere. Some executives are very nervous subjects and feel more comfortable with a hand prop to hold, so keep your eyes open for these as well.

It's a rare executive who is at ease in front of the camera; they don't like the feeling of not being in control. They're not professional models and are generally nervous about how they look. That anxiety is compounded by the poking and prodding that we as assistants have to do to get them looking good. Most business suits don't take well to the positions we put the executive in, so they have to be adjusted to appear normal to the camera.

This futzing with an executive's suit or hair has to be done delicately or the subject starts to feel self-conscious and may become uncooperative. The three major areas of difficulty are the jacket collar, the shirt cuffs, and the tie. The jacket collar often rides up above the shirt collar, making the subject look hunched over. Give the back of the jacket a tug down or ask the subject to sit on the tail of the coat to keep it in position. Also make sure the cuffs of the shirt appear below the jacket sleeve. Lastly, tighten the necktie so it covers the gap between the shirt collars and is oriented so it appears centered between the jacket lapels from the camera angle.

To help the executives feel more at ease, I approach the adjusting of their clothing much as a tailor would. Most of them have had their suits fitted by a tailor so they are accustomed to that. I also keep a patter going to occupy their attention while I go about redressing them. I tell them that it's not them, but the way the camera sees things, and that the best suits are not cut to take the body positions that we have to put them

into—anything to avoid making the execs feel like there is anything abnormal about them. It's entirely the camera's fault.

Applying makeup to a male executive is trickier still. Even though it is only a little face powder, most of them see the compact and stiffen right up. Harder still is approaching a bald man with the intention of powdering down his gleaming pate. I never approach a businessman like I am asking his permission to put powder on his face, but with a deliberateness that lets him know there is nothing unusual about it. Again I keep the patter going to distract him. I say, "These lights are very harsh so I'm going to put a little powder on to keep the shine down." I never use the word "makeup." For balding men I add, "These lights are very warm. This will help keep down the moisture." The execs are busy listening to me, and by the time they know what I am doing, I'm already done. Female execs will usually apply their own makeup.

The equipment used for executive portraits is much the same as what is used for portraits in general. The cameras are 35mm and medium format, and the strobes are most often a lightweight portable system, like Dynalite or Comet. Tripods, light stands, and grip equipment are limited to amounts easily transported.

One last tip. Be friendly with the freight elevator operator. He's the guy you will need to get all of the gear back out of the building when you are done shooting. Most freight elevators officially close at 5:00 P.M., but in reality stop running up to fifteen minutes earlier. Confirm with him what time the elevator "really" stops running and let your photographer know. Sometimes you can talk the operator into staying longer, but if not, you will have to find out how to get the gear down once the freight closes.

Industrial

The second half of this specialty is the product and facility photography. This work is particularly interesting. It's always a little bit different and puts your abilities to the test in creating a shot. All of your skills as an assistant are called into play when working industrial. The shoots are of everything from little still lifes to huge architectural shots with people. There are multiple light sources with which to contend and numerous obstacles to overcome.

For assistants with avid curiosities, like myself, industrial photography is very interesting. Not just for the photography lessons and tricks to be learned, but also for the insight into how things are manufactured. In my many years assisting industrial photographers, I have crawled inside high-tech military aircraft, seen fiberglass ship hulls built, fiddled with lasers, climbed chlorine gas towers, and even photographed a satellite destined for orbit. Far from the rarefied air of the corporate offices, you are in the factories and plants and test sites where all the real work gets done. It's been truly exhilarating.

Each photographer approaches shooting these facilities in a different way, but the basics apply. Keep your eyes open for any location or prop, no matter how humble, that could be useful for making an exciting image.

There is an element of danger to these assignments, however, of which you should be aware. Working in labs and factories exposes you to potentially hazardous conditions. As the assistant you will be climbing up to catwalks and working near chemicals and big machinery. You need to move carefully whenever working in these areas.

I once stepped into a cement pit, thinking that the small retaining wall around it was only the next step down the staircase that I was descending. The entire area of this gravel pit was covered in wet sand (the "fine pit," as it was called), and it looked no different from the rest of the ground. I immediately sank up to my crotch into this cold, wet, cement-like stuff; the freezing temperature instantly sapped all of the strength from my legs. When I had sunk low enough to grab the edge of the pit, I hauled myself out, trying desperately to keep my shoes from being pulled off by the suction.

Only after the photographer realized that I didn't have any of the shot film on my person did he start laughing. I, on the other hand, was quite annoyed. I was cold, my jeans and shoes were wet, and to top that off, the cement dried and I had to chip it off my legs. So, watch where you step.

Most industrial photographers use 35mm cameras for shooting on these locations. It is easier to carry the many lenses and accessories needed, for the varied types of shots involved, when working with 35mm. The strobes preferred are also small and lightweight, so more units can be brought along. Some photographers bring various light sources, like small hot lights or specialty lighting to get certain effects and to light zones not easily lit with strobes. Since rigging these lights in hard to reach areas is often a necessity, special clamps and stands are included in the grip case. A wider assortment of film and filters are packed to deal with the various lighting conditions.

Be prepared to do a little modeling when assisting industrial photographers. It's often quicker and easier to use an assistant to pose as a worker in a shot than to hunt down a willing or suitable employee. The assistant knows what the photographer is looking for in terms of body language and knows how to keep still for long exposures.

Over a dozen annual reports depict me as construction workers, law students, and chemical engineers. I posed for shots when others refused; it's not easy to talk a poorly paid worker into climbing a gas tower in January with no jacket on. Once I was even threatened with excommunication by a Polish priest for climbing to a windowsill in a church outside of Warsaw. Each time we got the shot because I was willing to do what no one else was crazy enough to be conned into. Hey, maybe I'm not so smart.

Shooting in these factories, foundries, and laboratories is hard on your clothing. They are rarely very clean, and you will be crawling around in very dirty, greasy areas. Invariably, the best place to rig a light is also the messiest. Jeans, T-shirts, and hard-toed shoes are the uniform for these shoots, clothes you won't mind messing up. Wear clothes without noticeable labels or writing in case you are pressed into modeling.

There is a lot of travel involved in corporate/industrial photography. You won't necessarily go to beautiful or exotic places, but you will rack up those frequent-flyer miles. Even when you do get lucky enough to get sent to an exciting destination, you won't often see much more than the airport, the hotel, and the factory. I think I've been through most major cities in the United States, but I couldn't tell you what they really look like.

Air travel with photo equipment is a nightmare for an assistant. The assistant spends the day loading and unloading cases into trunks of cars, off of conveyor belts and onto carts, back into a car trunk, and then onto another cart at the hotel. In between, the assistant gets to sit on a long flight between the person who has never heard of deodorant

and the screaming baby. There's also security to get through and the overhead luggage compartment to stuff. I'll explain more about getting through airports in Chapter 9, "Tips and Tricks."

Sprinkled in among the schleps to Nowheresville, U.S.A., are the trips that you will treasure. Certain jobs stand out in my memory because they sent me to foreign countries and involved shooting in a way that enabled me to see much of the area. I've been on assignment to Australia, New Zealand, Turkey, Italy, France, England, Ireland, Venezuela, and Jamaica, to name a few. They were all amazing places and I actually got paid to go there. Of course, I also have had to survive food poisoning and Montezuma's Revenge numerous times, but I wouldn't trade the opportunities I have had to see the world for anything. Although corporate budgets have shrunk in the last few years and foreign travel has dropped off, I hold out the hope that I will get a few more trips overseas.

Fashion Photography

One of the most exciting and dynamic areas of photography is fashion. There's an energy and a raw creativity to it that attracts many assistants. The reasons assistants go into fashion are as varied as the styles of fashion photographers. Whatever their reasons, there is so much being done in fashion that just about every assistant can find something of interest.

Fashion photography encompasses all images made of clothing and clothing accessories, most often appearing on live models. That is an oversimplified description, but fashion is such a huge category that this will have to suffice. There are fashion photographers who shoot high fashion, catalogue, women's fashion, men's fashion, and children's fashion in many different styles.

Fashion is shot everywhere, in the studio and on location, indoors and outdoors, in good weather and bad. The sets range from opulent room settings to simple seamless paper backgrounds. Just about every lighting style and shooting style can be found in fashion photography, from simple and clean to dramatic.

As widely varying as fashion styles appear, so too are the people involved in fashion. They are an eclectic bunch. Fashion attracts all kinds of people, and half the fun is meeting each new crew with whom you are to work. The crews tend to be large with sometimes several assistants, separate hair and makeup stylists, clothing stylists and their assistants, models, and several clients present, each with his or her own quirks.

Unfortunately, this quirkiness, at times, can cause the most virulent arguments that I have ever seen. There are egos aplenty in fashion. Many times I have tiptoed around sets to avoid getting into the middle of ego clashes.

As an assistant in fashion you need to be aware of what drives this industry in order to function within it. Fashion photography is a "scene," and many people, in all areas of it, have hugely inflated opinions of themselves—although I have worked for some very sweet fashion photographers. By and large the industry is full of highly creative but power-driven people. I think large portions of fashion people are as fickle as the clothing industry that drives it.

The small circle of top designers, photographers, and editors make the decisions about what is "hot" or what the new trend should be. The others, hungry to be at the top, jump on the bandwagon. These trends don't necessarily mirror the tastes of the average consumer. I will never understand that whole "heroin chic" thing, but when the fashion elite

snap their fingers, whole legions of designers, editors, stylists, and photographers stop what they're doing to follow along. Just when you think you've got a handle on it, they snap their fingers, and the trends change.

Because trends change so quickly in fashion, so does the equipment used. Fashion photographers are always looking for that new look that will make them popular and propel them to the top. They try whatever light sources tickle their fancy: fast recycling strobes that can keep pace with their rapid shooting style, tungsten lights, banks of fluorescent tubes, huge walls of sheer fabric, or immense umbrellas. It is difficult as an assistant who works infrequently in fashion to keep up with all of the new equipment in use. Personally, I follow the photographer's lead until I understand what the look is; then I can actively help improve it.

Scrims or butterflies are used quite frequently in fashion shot outdoors. They are large expanses of sheer fabric tied to assembled metal frames and come in many sizes, the largest being twelve feet by twelve feet. Photographers use them to soften and diffuse the light falling on the model. Unfortunately, the frames can be quite heavy and need to be mounted on "high boys": huge heavy stands with lockable wheels. The stands need to be weighted down either with people or every sandbag that can be found.

Wind wreaks havoc with the big ones. It's like raising sail. If a good wind comes along it's going over, no matter how many people you have standing on the base. A photographer and I once unlocked the wheels and let the wind roll us down the street. We picked up a lot of speed before it tipped over. Don't try this at home, folks; the sailing is fun, but the stopping isn't.

So, what's so different about assisting fashion, other than working with strange equipment and wacky people? There are several things that are important in a fashion image that mean little or nothing in other kinds of shoots. Of supreme importance is the look of the clothing; stylists will fuss over a single bend in the fabric until the cows come home. Along with your other usual duties as an assistant, you need to watch for problems with the product, loose threads, a distracting wrinkle, or seeing "return." Return is the opposite side or inside of a skirt hem. Most fashion photographers do not want to see anything but the front surface of the clothing.

Because fashion photography often involves a lot of movement from the models, an assistant needs to be aware of any changes of position by the model. As the model shifts positions or poses, many crucial elements may also change, like light exposure readings, and focus. The assistant has to quickly tell the photographer of these changes. If the photographer does not want to make alterations in exposure or framing, then the assistant will have to get the model back into position. When the model's feet are not seen in frame, the assistant can place a small piece of tape on the floor as a toe line to mark the model's position at a given exposure. Should all of the model appear in frame, then the assistant should mark the position by other means, either tape marks outside of the frame, or lining the model up with a physical feature in the area, like a window frame or pole.

A common action for a fashion model is to walk towards the camera. This presents technical problems for the photographer. First, it is hard to focus on a moving target, especially when the target is moving directly toward the camera. Second, unless the shot is done outside in sunlight, the exposure changes rapidly as the model nears the light source.

The photographer needs an alert assistant to deal with these difficulties. One way to avoid the problem of a walking model is to have the model "do the rock." The photographer will pick a position and focus on the model standing on that spot; the model then positions his or her feet to simulate walking and shifts back and forth. The model appears to be walking but never moves far from the mark; all the assistant need do is make sure the photographer is firing the camera precisely as the model's torso passes over the mark.

The other option is for the assistant to call out "Now," as the model hits the mark signaling the photographer to click the shutter. This requires expert timing between the assistant and photographer. If the photographer is reacting slowly, the assistant may have to lead a bit and call out a split second early, so by the time the photographer fires, the model is directly over the mark. Some photographers prefer this method, because they feel that the model's body language is more realistic than "the rock."

Another obstacle to shooting outside is the weather. Apart from the endless waiting for the sun to peek through the clouds, extreme temperatures test a crew's endurance. Not every client has a budget big enough to send a whole crew to a location where the weather is more comfortable, so they have to make do where they are. A crew may find they have to shoot in freezing temperatures or oppressive heat.

Since there is a lag time of several months between the time a shoot is scheduled and the publishing of the images, cold weather clothes are often shot in the summer and warm weather clothing is photographed in the dead of winter. That means, at least here in the Northeast, that the poor models have to run around on cold days in shorts and on sweltering summer days in sweaters and winter coats. Models are not happy about this arrangement, so the assistant tries to keep them as comfortable as possible. Shade them from the sun to keep them from sweating up a storm, or have their coats close at hand to warm them up in between shots. Hopefully the location van or "Winnie" (short for Winnebago) is parked nearby so they can run back and forth to stay comfortable.

The assistant, on the other hand, does not have the luxury of hanging out in the van. Whether it's hot or cold, the assistant spends most of the time out in the elements. When one shot is finished and the stylists and models have retired to the Winnie, the assistant has to drag everything to the next location, or just remain on set to keep a watchful eye over the gear. This is why it is important for assistants to wear appropriate clothing when working outside: multiple layers for the cold, and loose clothing for the heat.

No matter how well you tolerate the cold, bring along an extra fleece vest or shirt. Standing around out in the cold waiting for the makeup stylist to finish will freeze even the heartiest of assistants, and you will be glad you have another shirt to wear.

I froze on many shoots before I started wearing a fleece vest under my coat. The vest allowed me freer arm movement so I could still work while bundled up. Because I need bare hands while loading film, my fingers were numb and nearly frostbitten on many occasions, until I found these chemical heat packs that I keep in my pockets. After loading the film, I stick my hands in the pockets with the heat packs till they are warm, then put on my gloves again. I don't tell anyone else on the shoot that I have those things in my pockets, because I would soon find myself without any. Besides, I'm the one out in the cold for the longest periods of time.

The heat is another story. There is little escape from brutal heat and high humidity. Apart from wearing as little as possible and drinking plenty of water, there is little else that you can do. The cameras and film should be shaded from the sun, and find some for yourself as well.

I really commiserate with the models who have to wear winter clothes under these conditions. On an editorial shoot several years ago for winter clothes, the temperature soared to 104 degrees with oppressive humidity. The female models, whom we had shot all morning, were holding up like real troopers, but the male model whom we were supposed to shoot in the afternoon didn't arrive until very late. The client and photographer, after deciding that this guy was a no-show but desperate to get the shot, turned to the only other guy in the whole crew as a replacement—me.

I tried to dissuade them with every excuse under the sun. "I'm no model. Look, I've got hat hair. My glasses have made marks on the side of my nose." The last thing I wanted to do in that heat was put on a heavy winter sweater. After every excuse was shot down, I resigned myself to my fate. Halfway to the Winnie the male model arrived. I dropped to my knees and thanked God that he finally got there. Ever since that day I have gone out of my way to make models in that situation as comfortable as possible.

Still Life Photography

It doesn't always follow that smaller subjects are easier to shoot. Some of the most complex sets are built around tiny objects that require an entire day to light. Whereas some of the other specialties in photography stress shooting many images in a day, an entire day of work in a still life studio may produce only three sheets of exposed film. If I had to describe still life photography in one word, that word would be meticulous.

The name of this type of photography is fairly self-explanatory. Whether a still life is shot for commercial purposes or for artistic reasons, it is photography of anything that's not going to get up and walk away on its own. Most commonly it refers to objects smaller than a car. Though landscapes and buildings are not likely to move on their own, there are other photographers who specialize in those subjects.

Still life photography is one of the largest fields in the business. At some point most products manufactured will need to be photographed; that is a lot of photographs to be made. They need to be photographed for advertisements, catalogues, product box art, editorial uses, and a zillion other reasons. This is the job of a commercial still life photographer.

Far from the glitzy, high-energy world of fashion photography, still life photographers have to be deliberate and detail-oriented. They work as creatively and as intuitively as any other photographer does, but they also have to be capable of standing over a tabletop set and staring at a small product, all day long. The smallest change to the set or lighting can produce hours of correcting.

I've got to hand it to still-lifers for their tolerance. The amount of patience that it takes to place a highlight in just the right spot on a three-inch-long product is staggering. The smaller the subject is, the greater any movement of the subject or the lighting affects the image. With this kind of photography, a single dust speck can cause a re-shoot, so still-lifers have to worry about the tiniest details. Being this meticulous is also rough on their backs and knees; crouching or bending over a tabletop all day really stiffens them up.

Since still life photographers shoot almost all of their work inside their studios, their equipment does not have to be very mobile. When you assist in still life studios, you'll notice that they have slightly different equipment than photographers in the other fields. Many of their stands will be heavier and sturdier or have wheels attached. Because of their need for very small lens apertures and the greater depths of field these provide, they use bulkier, more powerful strobe units like Speedotrons, or use various light sources like big tungsten "hot lights," 1Ks or 2Ks, or little adjustable tungsten lights. Studio photographers may even opt for a camera stand instead of a tripod. These camera stands are tall rolling pedestals that are more stable than tripods. All sorts of light modifying and grip equipment can be found in use or lying around a still-lifer's studio.

Another piece of equipment that you won't often see in a location photographer's arsenal is a large format camera. Large format cameras, either 4×5 or 8×10, allow the still life photographer greater control in making an image. With the "swings and tilts" this camera provides, a photographer can alter lines of convergence and the depth of field. It may look like an old-fashioned camera, but with today's lenses and accessories it is far from outdated. The camera uses sheet film loaded into film holders that slide into the back of the camera, one sheet on each side of the holder. This is a very simplistic description of a large format camera, but I think you get the picture. Familiarize yourself with the use of this camera if you intend to assist in a still life studio.

One of the difficulties of using this camera is that there is no eyepiece through which to see the subject; instead, the image appears on a ground glass on the back of the camera upside down and backwards. Although photographers have long since grown accustomed to seeing an image this way, the directions they give you, as their assistant, on moving the subject may seem confusing. The directions they give you are geared around the image as they see it.

The first thing to learn when moving items around a set is to move them in small increments; photographers get testy when you move an item too far or too fast. Photographers are fine-tuning the image when they direct you to move things, so make the adjustments small until you are told to move them further.

Secondly, which direction items are to be moved depends on the area of the frame they are in. Peek into the back of the camera to give yourself an idea of position. When the photographer instructs you to move something "in," reposition the item in small increments toward what would be the center of the frame. Moving it "out" would be the opposite. "Away" means to move the object farther from the camera, and "down" or "closer" means the photographer wants it nearer to camera. These crazy directions are necessary because the image appears flopped in the ground glass, and it is easier for the photographer to direct you by what is seen rather than the actual direction.

Booms also seem to bewilder some assistants. A boom is a long pole that attaches horizontally across a sturdy stand upon which a light can be rigged. It's a very common piece of equipment and is found in most studios. It allows a light to be positioned above a subject without the stand appearing in the camera frame. Disasters happen when assistants neglect to counterbalance the weight of the light at the opposite end of the boom with a lead weight or sandbag. Without the counterbalance the boom will eventually tip over and the light will crash into whatever is below it. The time to add the sandbag is before the strobe head is attached. Put the boom together away from the set, just in case.

One of the reasons still life photographers use powerful strobe units is to get the maximum depth of field their lenses will allow. The more light striking the subject, the smaller aperture opening on the lens the photographer can use, like f-64. Sometimes, though, even a 4,800-watt-second pack is not powerful enough, so they have to pop, or fire, the strobe multiple times. This is possible only with objects that don't move; any movement will result in a double image. When firing more than one pop, everyone should stand still; any vibration of the floor could cause the subject or the camera to shift position slightly. Since each successive strobe flash adds an exposure of the subject onto the film, movement of the camera or subject position for any of the flashes will create a second image on the film slightly off-center, in effect blurring the shot and making it useless.

The procedure of multi-popping a strobe is simple; it's the execution that gets complicated. What the still life photographer does is to first turn off all ambient light that might strike the set. The shutter is opened and remains open until the end of the entire exposure. The assistant then fires the strobe manually the appropriate number of times. After the last pop, the shutter is closed.

The order can often get confused. Do the procedure the same way every time to make it a routine, and when popping the strobe, count the pops out loud. This will help you keep the number of pops straight in your head.

When working on a shot for which I have to multi-pop the strobe a varying number of times, I jot down the number of pops for each exposure on a little slip of paper. Although I could do them all properly from memory when given complete silence and freedom from distractions, I don't leave it to chance. Rarely is a photo studio distraction-free. Even the photographers are guilty of forgetting the number of pops, and many times I have had to count loudly to drown out the question, "How many are we doing?" so I could keep track of my pops.

Have you ever wondered why assistants wear black so often? Reflections. Many of the objects still-lifers shoot are highly reflective. Glass, silver, and even some glossy paper products pick up reflections from all over the studio, and these reflections are not always visible in the camera. Only after the film comes back do you see the errant reflections. By wearing black, you reduce the possibility that you will be seen in one.

I have assisted a few still life photographers is my time, and have even shot some still life jobs of my own, but I don't like to be cooped up in a dark studio all day. Outside in the sunlight and around people is where I prefer to be. I enjoy shooting still life on occasion, but since my main interests are images of the living and breathing, I assist those types of photographers most often.

Food Photography

A subspecies of still life photography that has grown into its own category is food photography. Since it requires highly specialized skills and a unique type of stylist (commonly referred to as a home economist) and a studio with a kitchen, this area of photography warrants its own category. These are the photographers who make all of the images of the food that we see in restaurants, magazines, and on food containers that make our mouths water. Though the photographs may be somewhat idealized versions of the actual product, it's the image of that steaming bowl of

yummy macaroni on the box that makes consumers buy the product.

My first assisting job was with a food photographer and it was baptism by fire. Aside from being two and a half hours late due to a train accident, I left a half-filled box of 8 × 10 film open when I turned on the light in the darkroom, ruining a lot of expensive film. Though I was ready to crawl off and die somewhere, the photographer was very forgiving. He knew it was my first gig and did his best to help me acclimate to working in a studio.

The product we shot was a blueberry-covered tofu cheesecake. When we pulled one of the three dozen cakes the client had sent us out of the box, it looked thoroughly unappetizing. Between the photographer and the food stylist, they made an image of a mouth-watering piece of cheesecake. I was relegated to leaning over the set moving tiny blueberries around the frame with tweezers. By the time the day was done, my back was aching.

Technically, food photography is similar to still life in most ways. The gear involved is the same, with only minor variations. The requirements of an assistant are the same in food as in still life.

One thing I learned about food photography is that it is a lot like making a movie: very little is really what it appears to be. As in a movie, a brick building facade may in reality only be a wooden flat painted to look like brick. So too are some of the foods we see in photographs. Because ice cream melts, mashed potatoes may be substituted; in the photo it looks just like the real thing. Coffee is frequently shot using gravy mix to avoid the grit floating in real coffee, and the lovely steam curling up from the cup is cigarette smoke blown through long straws.

I love this particular trick with smoke. Since I am a smoker, it gives me the opportunity to sneak a few puffs for myself. First, the studio needs to be completely still when doing this trick; any airflow will disrupt the smoke. Join together several straws to make one long one—little did my mom realize when she was telling me to stop playing with the straws at the dinner table that I would find a professional use for it. Then take a long draw on the cigarette and let the smoke roll gently through the straw onto the liquid, taking care not to touch the surface. Remove the straw slowly so you don't make a breeze, and voilà, you have steam.

Occasionally food photographers get to go on location. Some assignments require that the photographer work in a restaurant to shoot dishes prepared by a particular chef or to use the restaurant as a set. This presents the problem for the assistant of getting a studio-bound photographer and all the appropriate gear to the location. It's not fun hauling studio strobes around town; they're heavy.

A food photographer once came in from Chicago to shoot special dishes created by a few of the top chefs in New York. These chefs work at restaurants that I can't afford to frequent, so I signed on just to see what the places were like. The photographer had gotten my name from an assistant's list provided by APA to its members. Remember when I told you to get on those lists? This is why. Not only did we get to shoot great images, but we also got to eat the food that we didn't use.

One trick that I learned from this food photographer I use to this day. He travels with empty sandbags. When he gets to the restaurant, he fills them with potatoes and uses them to counterbalance the boom. This works with any heavy object, such as rocks or bricks or whatever you can find at the site. One equipment company makes a water-filled weight bag but I am too paranoid to use them. I don't like water being anywhere near the strobes that I am using. Better safe than sorry.

Beauty Photography

Beauty photography is a difficult category to define. Even its title is vague in nature. Beauty photography is generally related to the cosmetics, perfume, body and hair care industries, since these are the largest group of buyers for this type of image.

Any product that is involved in making a person beautiful, or is selling an image of beauty, would be in the realm of the beauty photographer. For example, an image of an attractive model wearing a certain lipstick would be considered a beauty shot. Many shots are less product-specific, but are used to portray an image of being or feeling beautiful that a company can just slap their name onto to hawk their wares, such as a nude woman lounging in a forest stream used for a soap advertisement.

An assistant will find that the equipment used by beauty photographers is generally the same as that used by other photographers, both for studio work and on location, with only a few additions. Beauty shooters tend to use "round" light sources more often than others do. They use light-modifying equipment like large umbrellas or "beauty dishes"—round, hard, shallow reflectors attached to the front of a strobe head—to create a crisper light on the subject. Some even use a special strobe called a "ring light" mounted around the camera lens to get a specific lighting effect.

Since it is imperative that the model look as perfect as possible, the hair and makeup stylist is crucial to this type of photography. A single strand of hair out of place can be very distracting in the final image, so the stylists are meticulous. Much of your time assisting a beauty photographer will be spent waiting for hair and makeup to finish. Come to think of it, most times that you work with makeup stylists you spend time waiting for them; those who work quickly and well are worth their weight in gold. When you come across those who do both, get their promo cards and keep them in mind for your own shoots.

Because of the nature of this type of photography, beauty models often have less prudish opinions of nudity. They are very comfortable with their bodies and see them more as professional tools. As a result it is not uncommon to see one strip for the shot or change wardrobe in full view of everyone in the studio. Beauty and fashion shoots often require quick changes that force models to undress with a whole crew present. They may not like it, but it can be a practical necessity at times.

The first time a model did this in front of me, I nearly swallowed my tongue. Blushing furiously, I found something else to do in another part of the studio.

Being nude is a vulnerable position for anyone. Having to be nude in front of a whole crew is particularly awkward for some models, so it's not a bad idea for an assistant of the opposite sex to set up a workstation—loading film, taking notes—in an area out of direct view of the nude model. The assistant still needs to do the job of checking lights and feeding the photographer film, but the less an assistant is seen under these circumstances the more likely a nervous model is to relax.

Illustration Photography

The most concise description of illustration photography comes from a book written by Jack Reznicki, one of my photographers, and aptly titled *Illustration Photography*. In the book he states, "Illustration refers

to the fact that I am asked to illustrate a specific idea or mood for an advertisement by means of my photography." I think that says it rather well. When a client needs a shot of a lonely grandmother, they call an illustration photographer.

An assistant should expect just about anything when walking into an illustration photographer's studio. One day it's a hand model on a small tabletop set with white seamless paper, and the next it's an elaborate room set built to hold several people complete with tile floors, French doors, and a grand piano. Sometimes set builders are brought in; other times building the set is up to the photographer and the assistants. Assistants are definitely kept hopping. All of an assistant's skills are brought into play when working in this field.

Illustration photographers use every piece of equipment imaginable to get the job done. Because of the diverse natures of their assignments, these photographers use various types of lights, cameras, and other gear. When they go on location, they tend to bring the whole studio with them. They pack booms, rolling stands, four-by-eight-foot foam-core, more stands than a movie crew would need, and if they could figure out how to get the big camera stand out of their studios, I'm sure they would try to bring that along too.

I worked for an illustrator once who packed a sixteen-foot rental truck full of gear for two small location shots. I doubt that the other assistants and I opened more than three cases or used more than a quarter of the stands packed into the back of that truck. I agree that it's better to bring extra equipment on the chance that it might be needed than to leave it only to find that it would have helped, but I still think this guy was a bit excessive.

Sooner or later you will meet just about every type of worker in photography at an illustrator's studio, like set-builders, model-makers, stylists of every ilk (hair, makeup, clothing, and set), baby wranglers, animal handlers, and models of all ages and looks. You will also become well known at the prop houses, set shops, and backdrop rental studios. These places will become a second home to you.

Assistants looking to work for an illustrator should have a broad range of experience with the various types of lighting and grip equipment. They should also have at least rudimentary light carpentry skills, enough to use a power drill, screw gun, and electric saws. At times, assistants will have to erect room sets or build "flats"—set walls—that might require these tools.

I've learned so much carpentry in illustration studios that I recently stripped my bathroom floor down to the beams and rebuilt it better than it had been built before. It wasn't always that way, though. I remember one incident in which I swore to a photographer that I couldn't drill through a pipe because the drill bit was too worn. After trying for thirty minutes, I was making no headway. The photographer sent me out for a new high-grade bit, which cost quite a bit of money, to replace the one that was worn out. I used the new bit with no better results. Afraid that the drill was the trouble, the photographer looked the tool over—only then did we realize that I had been using the drill with the speed switched onto "reverse." Duh!

Casting, or the process of hiring models to be used in the shot, is another big part of illustration photography. Just what an assistant's duties are during a casting is up to the individual photographer. Some photographers turn the casting completely over to the assistant, while others will alternate shooting the casting with the assistant.

On many of the jobs that come through an illustrator's studio, a casting will have to be done to give the clients a choice of models to be considered. Model agencies are called up and given brief descriptions of the job and the type of model wanted. Depending on how elaborate the casting is, the agencies may just send over several composite cards, sample cards with various photos of the model on them, or may arrange to send the models to a casting session arranged with the photographer. Several model agencies may be called and hundreds of models may show up.

At the casting session the photographer may or may not look at the model's portfolio, but generally a Polaroid or sample photo will be taken of the model. That is the longest minute and a half of a model's life, nervously waiting for that Polaroid to develop. Meanwhile, they hang over the assistant's shoulder. If they don't think the shot does them justice, many will pester the assistant to shoot another even though there may be twenty other models waiting for their own turns. Castings can turn into total bedlam when several models show up at once, particularly when casting children.

Architectural Photography

Photographs of buildings and their interiors fall under the category of architectural photography. Some buildings are photographed solely because they have been designed with such skill and esthetic beauty that they warrant being named works of art. Other buildings, or portions of them, are shot for other reasons, such as real estate sales, or for use by the architect or designer. There are photographers with such a love of architecture that they have made it their specialty.

Most of this work is done with large format cameras to control the lines of convergence caused by the angle by which a structure is viewed. Without the aid of the tilts and shifts of a large format camera, or the use of a special "shift lens," the walls of buildings, when viewed from the ground, will appear to converge, or move closer together at the top of the structure. The tilting and shifting ability of cameras and lenses corrects this optical effect to make the walls appear straight in the image. I won't begin to explain the science behind it, because it will put you right to sleep.

The clients who commission these photographs may be the owners of the buildings or the architects or designers who have worked on them. If the designer or architect has hired the photographer, he or she may tag along on the shoot to guide the photographer to the areas of importance; otherwise, architectural photographers often work on their own. If it wasn't for the need to carry such heavy gear on location, I think most architectural photographers would chose to work completely on their own.

While shooting the exterior of a building there is very little an assistant can do other than take meter readings, hand the photographer the 4 × 5 film holders, and be an extra set of eyes to watch the gear and, maybe, an extra set of hands to clear away a little litter. If necessary, the assistant may also be used to block pedestrian and vehicular traffic from entering the frame. Unless the assistant is attracted to architecture, this kind of photography may seem quite dull. I've stifled more than a few yawns while trying to stay warm in the early morning hours on exterior shoots of bland buildings.

When shooting interiors, the photographer may opt to add some lighting. Either tungsten lights or strobes are employed, as the photographer prefers. The assistant handles these lighting situations as in any other shoot, setting up the lights and watching that they continue to work throughout the exposure. Foot traffic may also need to be redirected away from the shot while doing interiors.

The photographer wants the greatest depth of field possible. After all, buildings are rather large subjects. To get the very small apertures necessary to focus on an entire building, exposures can become very long, up to a few minutes in some cases. Assistants should have good watches with them to help the photographer time the exposure. Just as still life photographers lose track of how many pops of a strobe they have made, an architectural photographer may forget how long the shutter has been open. It's not hard to do during a long exposure.

For a short time a few years ago I worked with an architectural photographer on a very interesting project. We shot the renovations being done on a landmark theater here in New York City, from start to finish. Over several weeks we returned to shoot various bits of the restoration, both detail shots and overall shots. With the beautifully detailed plasterwork around the theater, I could easily see why some photographers make architecture their livelihoods. When the restoration was completed, we were asked to photograph the cast and crew of the late night television show that took up residence in the theater.

Another photographer insisted on shooting a Greenwich, Connecticut, estate from the air. The grounds were amazing: sculptured gardens around a beautiful mansion with an outdoor pool that led through a tunnel into the house. Well, the photographer was petrified of flying in a helicopter. Having had a little experience myself with helicopter shoots, I briefed her on all the safety instructions. But even when she was strapped in, she wasn't able to relax until I promised to keep a tight grip on her jacket as well.

It's not easy in the best of circumstances assisting in a helicopter shoot. The door is open so it is freezing inside. With the helicopter banking and turning, anything left lying around goes flying around the cockpit, so every lens and film back must be put back into its case or into your pockets. A shoot vest really comes in handy when shooting from a helicopter. Now add to that a nervous photographer who insists, on top of everything else, that I keep one hand holding onto her, and you've got one great feat of manual dexterity on my part.

Portraiture

Portrait photographers are the opposite of illustration photographers. Whereas illustrators use people to illustrate an idea or mood, portrait photographers try to get accurate portrayals of the people themselves. Portraitists try to draw out the personality of each subject, what is unique to that subject. I think a truly good portrait tells a story about a person, even if it is just written in the eyes.

How deeply a portrait delves depends on the purpose of the photograph. Corporate portraits have less to do with the individual than portraying an image that the company wants to project. In a way, this kind of portrait is like a photo illustration. The company wants the image to say certain things about its executives that speaks more about the company, a facade of confidence and trustworthiness.

Many people who are placed in front of a camera put on another face. They smile fake smiles, or they wear a "public" face. Getting through

that facade can be difficult, but one of my photographers taught me a way to do just that. People put on that veneer when they anticipate that the photographer is about to take the picture, so we fool them; the photographer doesn't hunker down behind the camera and tripod. When the frame is set the photographer steps back from the camera and engages the subject in conversation, keeping a finger on the shutter release. Seeing that the photographer is not looking through the camera, the subjects no longer anticipate the photograph; they revert to themselves, and the photographer can shoot, getting spontaneous expressions.

I have used this myself in my new work. Working out on the road, I shoot portraits of some of the "real people" whom I meet. I have already created a rapport with these people, in convincing them to allow me to photograph them, by the time I set up the camera. I continue a light banter with them to distract them from the camera sticking in their faces, often stepping away from the camera to fool them into believing that I am not shooting at that moment. Guiding them to the natural expressions that I want through the conversation, I wait for their personalities to shine through and then shoot.

Assistants working for portrait photographers need to be fast on their feet. The windows of opportunity to get the shot open and close in the blink of an eye. Reflectors and lights have to be ready when that time comes. It is also a good idea to "cover" the camera when the photographer steps away from it during a shoot.

Unless assistants are doing something, like holding a reflector, that keeps them physically away, it is a good idea to stand ready at the camera in case that window opens and the perfect expression happens while the photographer is out of position to shoot it. If the opportunity presents itself, the assistant should shoot a frame and then back away quickly to allow the photographer room to move in and continue shooting. This happens quite a bit when working with children. The photographer may leave the camera to play with or tickle the kid, and in the time it takes for the photographer to get back to the camera the expression on the kid's face is lost.

Some photographers freak at the thought of an assistant shooting anything on their job, so ask them first if they want you to cover the camera when they step away. Others are very appreciative of that kind of initiative. Know your photographer before you do this.

Celebrity Portraits

Celebrities need portraits for many reasons: some are for press releases, some are to accompany articles written about them, and others are for advertisements featuring them. The images run the gamut from their true personalities to their public personae. Whatever the usage, there are portrait photographers who specialize in working with these people.

It's not easy to work a celebrity shoot. There is so much politics going on behind the scenes that I'm surprised that anything ever gets done. Not only do assistants have to do their jobs, but they also have to maneuver through all the egos to accomplish anything.

The egos are so thick you could walk on them. The celebrities have been bowed and scraped to so much that they expect that treatment from everyone around them, often showing up late to shoots just because they can. Clutching the coattails of most celebrities is the entourage. These are hangers-on who will do everything to make the

shoot as difficult as possible, all in the name of looking out for the best interests of their celebrities. They also insist on preferential treatment from assistants, solely on the basis of their relationship to the "star."

I've seen members of the entourage step into a shot and announce to the photographer that the wrong side of the celebrity's face was being shot, and proceed to instruct the photographer on which side of the face they, in their "highly skilled opinions," thought was better. I wanted to ring their necks with every interruption.

Some celebrity photographers develop monumental egos themselves. Whether they put on airs to temporarily make themselves appear unassailable, to back off the other egos that threaten to interfere with the shoot, or really are full of themselves, it is awkward for an assistant to do the job and kowtow simultaneously. As long as the photographer respects the assistant and the job the assistant does, certain eccentricities can be overlooked, but no assistant should have to endure a photographer who views assistants as drudges.

I'm just not into that scene. I will do my all to help any shoot go smoothly, including swallow a bit of pride and do jobs I would rather not do, but I won't be looked down upon by an egomaniacal photographer for doing it.

As you can probably tell, I've had some very bad experiences in this field of photography, and hold a low opinion of these "super-egos." Not every celebrity or celebrity shooter is full of themselves, though. I've also met some very personable sports legends and entertainers on shoots—I had a very nice chat with Arnold Palmer once about his dog. I just get prickly around people who have to inflate their own sense of self-worth by making others feel inferior.

The Rest

Now, there are several other specialties about which I'm not going to go into great detail; I'm sure you will all be thankful about that. The purpose of this chapter is to give you an idea of what to expect while assisting in the fields mentioned, because these are the areas for which you will most likely have the opportunity to work. They are by no means all of the specialties. Photographers shoot many other categories, like cars, landscape, sports, and weddings. I don't want to shortchange them by failing to mention them, but neither do I want this book to become an encyclopedia of photography. So, to any photographers who are reading this book and whose fields of expertise are not mentioned, I offer my humblest and sincerest apologies.

Usage

A factor that affects every shoot is the usage for which it is intended. Three such usages that may alter a photographer's approach to a shot are advertising, editorial, and catalogue. Though these usages affect other aspects of the shoot, like billing, I'm going to stick to how they affect you, the assistant. Your job will not change, nor should your approach to assisting alter, due to the usage, but the elements of the shoot around you may differ, and you will have to take them into account.

Advertising

The advertising industry is a large buyer of photographic images. Because the assignments are directly linked to the success of selling a

product or a service, the budgets tend to be a little larger than for other uses. Productions can be made bigger when there is money behind it.

What does this mean to an assistant? For one, an assistant is more likely to get a full day-rate fee, as opposed to the lesser fee some editorial photographers pay. For larger budget jobs the assistant may also get hired to work for pre-production days, such as set-building, propping, the casting of models, and picking up rental equipment, and for post-production days to take apart sets, return the rentals, and run film to the lab and client.

Editorial

Editorial budgets often are much smaller than advertising ones. The images are used for magazine articles or other periodicals. Many photographers choose to do editorial shoots because they often allow a greater amount of artistic freedom, but for others, like fashion photographers, editorial is their bread-and-butter. Editorial shoots also are used as exposure for the photographer; having one's photographs appear in a national magazine can lead to other clients seeing them and booking the photographer for other jobs.

Photographers are paid per "story," per page, or per image used. Because photographers are paid less for these shoots, there is often not enough to pay an assistant the full day-rate that the assistant normally charges. There is also rarely room in the budget to hire assistants for pre- or post-production days. More work may, for financial reasons, get crammed into one day.

It is up to assistants to decide for themselves whether they want to work for less money, but I always look at it this way—getting paid something is better than sitting at home and not getting paid at all. Every shoot presents the opportunity to learn something or meet someone that might benefit me as an assistant or possibly as a photographer.

I work for an editorial shooter who photographs golf courses. Being a fan of the sport and enjoying the opportunity to go out and see private courses that I wouldn't ordinarily be allowed anywhere near, I assist this photographer for a smaller day-rate than I usually charge. Sometimes we are even allowed to play the courses while waiting for the light to be just right. Personally, I like the photographer, and I prefer to work with him for less than the usual rate rather than to sit at home waiting for the phone to ring.

Catalogue

It may be a tad simplistic to describe catalogue shooting as stressing quantity over variety, but scheduling as many shots into a day as possible is the reality of this type of photography. Less complex shots are usually planned with fewer variations of setting, lighting, or camera angles to accommodate the higher volume of shots to be done in a given day. Catalogue shoots may last up to a month or more due to the large number of subjects to be photographed.

Staying on schedule is all-important. You can't take too long on any one shot or you will have to make up that time somewhere else, usually by working late that night. Assistants need supreme organizational skills to keep up with catalogue. Studios can get crowded quickly with product, and it's the assistant's job to know which have been shot and where the next product to be shot is. It's a bit like assembly line photography, but the steady work can really line the assistant's pockets. Detailed film notes are also critical to keeping track of everything.

Some models I know have come back from catalogue shoots in Asia with horror stories of doing 125 shots in a day. They weren't allowed

time to leave the set to change; the stylists just stripped them right there on the set and put the next outfit on them, all day long. The clients and photographer were even loath to let these models leave the set to eat or use the bathroom for fear of falling behind schedule. This is a bit extreme, but you can see the priorities of catalogue shooting.

Now that you know, in a general way, what photographers shoot and what you will have to do as their assistants, you can make some decisions as to which photographers for whom you would like to work. Let your own interests in photography and individual personalities guide you in choosing photographers. Although I enjoy shooting still life images on occasion, my lack of patience for standing over a tabletop all day long and my desire to travel lead me to work most often for photographers who primarily shoot people on location.

7

Interviews

There are two perspectives on assisting from which I cannot give you firsthand information, because I am neither a woman nor have I ever worked for a big name photographer. In this chapter I have included interviews with assistants who have one or the other of these two perspectives to provide you with a more complete view of assisting. Whether or not you are female, chances are you will work with female assistants, so it is important to understand how their views of the business differ from male assistants. Working full-time for a big name shooter can be a very different experience from just freelancing around town;

for those interested in assisting for a famous photographer, this will give you the opportunity to get it "straight from the horse's mouth."

Interview with a Female Assistant

Assisting is no longer a male-dominated business; there are many female assistants out there, so it is important to hear about assisting from a woman's perspective. At least half of the attendees of the seminars that I produce are female, and I've seen a big increase in the numbers of female assistants over the past few years. There is no tangible difference in being a female assistant, just in other people's perceptions of women in the business.

This first interview is with Stephanie Tracy, a former student of mine, with whom I have worked on numerous occasions. She approached me after one of my seminars and impressed me with her quick mind and good attitude toward assisting. What she then lacked in experience, she more than made up for with her willingness to learn and desire to improve, so I felt comfortable with referring her to some of my own photographers. I do that very rarely.

Q. How did you get started assisting, Stephanie?

A. I got interested in photography while I was a student at a local community college, but actually got started in the business as a photographer. A company that shot sports team photos hired me to shoot these group shots on weekends and evenings. From the school jobs bulletin board I got jobs shooting weddings, parties, and model composites.

After a while, I burned out on shooting the parties and teams because I was no longer learning anything. Fellow students were earning good money and learning a lot by assisting, so I thought I'd give it a try. I got some jobs assisting wedding photographers, at first, and then a full-time gig with a corporate/industrial photographer from a classified ad in *Newsday*.

Q. How long have you been assisting?

A. I've been assisting off and on for about six years, while still shooting my own jobs on weekends.

Q. What kinds of photographers do you work for?

A. I work for a variety of photographers. My photographers shoot still life, illustration, wedding, and corporate/industrial photography, to name a few. I want to learn, so I keep things different.

Q. Do you think that there is a bias against female assistants?

A. Absolutely. The first reaction of some photographers to a female assistant is to question if they are physically capable of doing the job. There is often heavy lifting in assisting, and many male photographers assume that just because I am a woman I can't hack it. Some of them have even tested me at interviews, asking me to lift one of their cases to prove that I can do it. Even some of the photographers for whom I already work don't call me for certain jobs because they think that I won't be strong enough to do them.

In general, though, I think most photographers are more concerned with placing the right person with the right job. I am capable of doing any job a male assistant can do, but it may be more expedient to assign certain duties to a physically stronger person, male or female. There are plenty of jobs in assisting that don't require anything more than a quick mind and skill with the equipment. Let the "no-necks" do the heavy lifting.

Q. How does that make you feel?

A. I resent it when photographers assume that I can't lift their gear or ask me to prove that I can. In sheer physical strength maybe I can't compete with many men, but there is always more than one way to get a job done. I may have to put a case on a cart, or pack it in a more efficient manner so that I am able to carry it, but I can still get it to where it needs to be.

Q. At first one of my female coworkers felt I was being condescending by assigning her duties like making the coffee, while I hauled around the heavy stuff. Then one day she tasted my coffee, and she understood. I'm actually banned from making coffee in several studios; I make terrible coffee. Do male assistants treat you differently on the job?

A. Some do, yes. A few of the male assistants with whom I work automatically pick the chores that require greater strength. I'm all for letting them throw their backs out, leaving me to work camera. On set, it's all about getting things done quickly, so if they feel it's faster for them to carry something, they opt to do it, even though I could have done it. There's no malice in the choice, though.

Q. Do you think that certain biases for or against female assistants are justified?

A. Some of my photographers shoot a lot of executive portraits, and they like to use me for those shoots because they feel that the executives are more comfortable with a woman fixing their suits or putting makeup on them. I agree. I think, being a woman, I am able to work in close with a male subject without intimidating him the way a male assistant might. I'm also more comfortable with adjusting a woman's wardrobe or makeup than many male assistants would be.

I assist on many jobs in which we shoot "real people," and I find that as a woman I am able to approach them more easily than a male assistant would. This is especially true with children. Kids most often feel more relaxed being handled by women.

If a photographer is just looking for a strong back, a female assistant may not be the way to go, but a good assistant is more valuable to a photographer than one who can bench-press 200 pounds all day long. I think it has more to do with whom the photographer gets along best, personally. Compatibility between a photographer and assistant is very important. Some photographers prefer the company of men over women on the job; they share common interests. You can't fault someone for working with people who they like having around.

Q. Have you been able to take advantage of being a female assistant?

A. To a minor extent, yes. There have been one or two jobs over the years for which I was hired to do some additional styling or makeup. The average male assistant would not have been skilled in those areas.

Q. What advice do you have for other female assistants?

A. Assisting is a very physical job; it helps to be physically fit. Build up your strength so that you don't hurt yourself doing all of that lifting. If you are not capable of doing something, look for another means of getting it accomplished. Most importantly, though, become the best assistant that you can. Know the equipment and work hard.

Interview with a Big Name Photographer's Assistant

To introduce the big name photographer in question here, I quote from his own press release: "Jay Maisel's name is synonymous with color photography that uses light and gesture to create images for advertising, editorial, and corporate communications. In addition, his work appears in books, as well as in private and corporate collections. Among his awards are two from ASMP: Life Time Achievement and Photographer of the Year, and the International Center of Photography's Infinity Award. He has also been recently inducted into the Art Directors Club Hall of Fame." Geoff Green has been his first assistant for the last two years.

Q. How did you get started in assisting, Geoff?

A. I fell in love with photography while I was an anthropology major during my junior year at the University of Buffalo. I got my degree in anthropology, but added a minor in fine art photography. Once I graduated, I had no idea about how to get started as a professional photographer. A fellow student suggested that I start assisting; that way I could learn the business from the inside.

Q. How long did you assist before going to work for Jay, and what other kinds of photographers did you work for?

A. I only worked for one other photographer before Jay, and then only on one job. I had been looking through the job boards at school and the newspapers when I came across Jay's ad in the classified section of *The New York Times*. He was advertising for an assistant so I called up.

Q. Were you familiar with Jay's work before you started to work for him?

A. Not really. I was in a fine arts program at school. His name was never mentioned in class. I had read a couple of articles on him in a magazine, but I really wasn't familiar with any commercial photographers.

I was shocked. Sitting in front of me was an assistant who had landed a job with one of the top photographers in the world, and he was telling me that he was almost completely inexperienced with assisting, and that he didn't even really know who Jay Maisel was when he interviewed. Now, I'm not one to keep track of who's hot and who's not, but from early on in my career as an assistant even I knew of him and his work.

Q. You say you had no experience with assisting before you interviewed with Jay. Why then did he hire you?

A. I don't really know. During the interview, I was asked if I would be okay with keeping the front of the building clean, sweeping the sidewalks, and picking up trash. I said, "No." I wanted to assist him, not be his garbage man. He seemed to like this honest answer; Jay and his studio manager laughed.

Q. So Jay trained you as an assistant?

A. For the first three months, I worked closely with the first assistant who was leaving. I watched how he worked with Jay on shoots, and he and Jay both taught me how they wanted things done.

Q. What are your responsibilities as his first assistant?

A. Well, since I'm on full-time, I am available to do whatever is needed at any given moment. I assist Jay on shoots in the studio and on

location, as well as handle production, putting together estimates, sending out portfolios, and handling some stock-photography sales.

Q. What do you like best about working for Jay?

A. I like the excitement of putting together a last-minute shoot. Jay is always shooting, both jobs and personal work; he has constant energy. I also appreciate his intuitive approach to photography and the way he pushes himself to get a great image. Working for someone like that gets me to push myself and my own photography to higher levels. The steady paycheck from working full-time is an added bonus. With the money I am able to afford my own shooting.

Q. Are there any drawbacks to working with Jay?

A. Well, working full-time with any photographer can really drain an assistant. By the end of the day I am really beat. Sometimes it's hard to get motivated to do my own work, but since I do a lot of street shooting, I shoot on my way to and from work.
Also, working for someone as dynamic as Jay Maisel, it is hard sometimes to separate my work from his. I don't want to be a Jay Maisel clone—not that it would be a bad thing—but, being exposed to his images on a daily basis, it can be difficult to get him out of my head when shooting my own work.

Q. What are you learning from working with Jay, that you might not learn by assisting other photographers?

A. Since I'm there all of the time, I see a shoot from beginning to end, so I've learned how to do every step. I've also learned how to protect an image by filing for copyright, and how to deal with getting clients to get them to return images after they are done with them. You would be surprised by how many clients neglect to return film. Jay shoots jobs that cover the whole spectrum. He shoots everything from studio portraiture to industrial photography. His jobs run from big budget shots to small ones, so I am getting experience with all of it.
Because Jay is great at seeing the juxtaposition of the objects and details of an image, I've learned to be more aware of the little things in my own images. A photographer is responsible for the entire frame; nothing is unimportant. If an object is not effective it shouldn't be there. You have to see that. I am starting to work that into my mindset, eliminating or including.

Q. Tell us about a typical shoot with Jay.

A. I keep a couple of camera bodies over my shoulder prepped with the lenses I think he is going to use. Things go along smoothly while he is preparing for a shot, and then there is a sudden burst of intensity and, boom, he gets the shot. He knows right when he gets the shot, and then the intensity subsides and he moves on. Jay is willing to wait for that right moment. His assistants can't get flustered by what's going on or by the speed of it.

Q. What have been the most exciting shoots for you?

A. One would definitely be the time we traveled to South Africa. It was sort of a mundane assignment for me, but it was the first time I had ever been out of the country. The other would be the helicopter shoot over Manhattan. It was exciting visually to be flying low over the city, and physically to be in a helicopter for the first time. The feeling of taking off and doing the tight turns, in which the helicopter is nearly on its side, was great.

Q. What advice do you have for a young assistant who wants to work for a big name photographer?

A. Go for it. Don't hesitate to approach them. Even the elite photographers need assistants and keep résumés on file. There is always a chance you could get lucky.

It also makes sense to know who you are working for and that you are able to do for him or her what will be needed. Know what the demands on you will be before plugging them for a job. Learn by keeping your eyes and ears open, but don't be afraid to ask how to do things; it slows the pace down when they are done wrong. The pace can move very quickly with Jay, so you have to keep your head on your shoulders. I understood in the first day that I would have to move quickly here.

Q. What do you plan to do after you are done working for Jay?

A. It is a struggle for me right now, between my focus on fine art photography and commercial photography. I want to continue my fine art work, making the kinds of images that I do best, but I understand commercial realities. I would like to stay with Jay until my portfolio is ready to take on the world and I learn how to break into the business on my own. I really don't want to leave where I am to freelance, but I am leaving my options open.

I have to admit that I was a bit surprised by some of Stephanie and Geoff's answers. Being a freelance assistant I rarely have any say as to who gets hired to be my coworkers; I just work with whomever is there at the time, male or female, and expect them to do the same job regardless of their sex. Assisting is a very physical job, and I can see how many photographers may be cautious about hiring women, but Stephanie is right: there is always more than one way to get a job done.

Assisting big name photographers I always thought was the realm of "super assistants," assistants who knew everything and performed feats like reassembling strobe packs with their eyes closed. It took me a while to believe Geoff had next to no experience when he landed the job with Jay Maisel. As a rookie he got hired by a photographer I used to tell myself, "One day I'll be good enough to assist even him." This is a lesson for every assistant—don't take anything for granted. Find out for yourself.

Just when I think I know what I'm talking about, someone comes along to show me another side. I guess it goes to show that even experienced assistants can still learn a thing or two.

8

Safety

Safety first. There are plenty of ways to cause damage on a photo shoot. Not only can you accidentally break expensive equipment, but you also run the risk of hurting yourself every time you step on set. This is no office job where the biggest disaster is a wicked paper cut. On photo shoots assistants are exposed to high-voltage electricity, sharp knives, complex overhead rigging, and the need to climb into places that would make a monkey think twice. One photographer I know is fond of saying that he could teach a chimp to do an assistant's job, but the flaw in that statement is that a chimp is too smart to take the risks that some assistants take on a daily basis just to get the shot.

No photographer will begrudge the extra few seconds it takes for an assistant to do the job safely; broken equipment and bleeding assistants tend to interfere with the smooth running of a photo shoot. A good assistant will do the job as quickly as possible without crossing that safety threshold. Repairs are time-consuming and costly, both to equipment and assistants. Most accidents happen because an assistant is rushing or not paying attention to the job at hand. Knowing what dangers lurk around a set, an assistant can prevent most disasters, or at least minimize the damage.

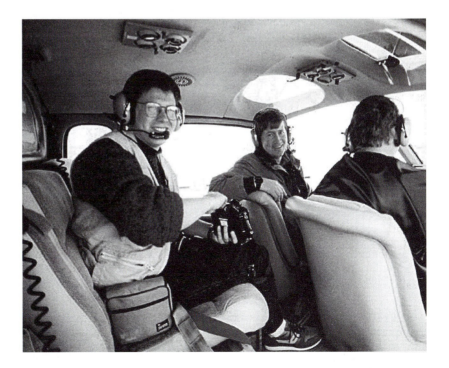

Equipment

How often have you handed someone a cup of coffee only to see the cup shatter on the ground because you let go before the other person had a good grip on it? We've all done it. Each person, thinking the other has the cup, lets go and it falls. Well, it's a slightly more expensive mistake when that happens with a lens or a camera. That kind of simple clumsiness can enrage a photographer and get an assistant fired.

Cameras and Lenses

When passing a photographer delicate equipment, like a camera or lens, it's a good idea to verbally confirm that the photographer has a firm grip on the item before you let go. Ask the photographer, "Got it?" and wait for a reply before you release your grip. If you don't get a reply, wait until the item is lifted out of your grasp, but keep an eye open in case the photographer drops it.

I've saved quite a few film backs from smashing on the floor by not trusting that photographers have a firm grip on them, even when they say that they have, by either catching them as they fall or sticking my foot under the falling backs to ease the impact. It doesn't do my toes much good, but it prevents the film backs from breaking.

Handing photographers the equipment in a way that requires the least amount of fumbling on their part to use it will reduce dropping incidents. All photographers mount cameras, lenses, and film backs differently, so hand the equipment over in a manner that orients the item correctly for use by each photographer without its having to be rotated or flipped once it has been placed in that photographer's hands. It's a distraction to photographers to have to flip lenses around to fit them onto their cameras. Apart from wasting their time, it increases the risk that they will drop the lens.

Photographers frequently step away from the camera without tightening the tripod. An observant assistant will check that the tripod head is securely tightened when the photographer does this, especially when there is a heavy lens on the camera. The lens can be severely damaged by flopping forward on the tripod head. Most photographers will tighten the tripod just enough to keep the camera from shifting for short periods, but if the shooter is away from the camera for an extended time, the assistant should tighten it, just in case.

Another potential disaster lurks on the set cart, or wherever you set up the spare camera equipment and film while you are working. This area seems safe enough, but add the cup of coffee that the client and photographer repeatedly place there and you have the beginnings of a real mess. Camera equipment and film do not react well to having coffee or other liquids spilled onto them, so keep all liquids away from any areas that have cameras and film. As much as you would like to growl at people for being dumb enough to put their drinks down on the set cart, just move them yourself and remind the offender, politely, not to put liquids near the cameras or film.

Better Safe Than Sorry

Whenever photographers hold a camera over a railing or other area where dropping it would mean its complete destruction, put a strap on the camera for the photographers to secure around their necks. If the camera is on a tripod in this situation, either weight or tie down the tripod to keep it from going over the side. This may seem paranoid to some people, but if the photographer does drop the camera, you'll wish you had strapped it down.

Lighting and Grip Equipment

Having eyes in the back of their heads would be a big help to assistants, but since they don't, they have to continually scan a set for potential disasters. There is a lot of truth in that old saying, "An ounce of prevention is worth a pound of cure." I'm sure it will come as a great surprise to my mother that as a child I actually *was* listening to her as she shook her finger at me and lectured me with that saying. Many of the accidents that occur on photo shoots can be avoided by using a little common sense and preventing the situations that cause them.

Any time that tripods or light stands are put in positions that create the risk of tipping over, such as being on uneven ground, in heavy wind, or being weighted to one side (as with boom stands), the assistant needs to take steps to see that they don't fall over. Sandbags are priceless in these situations. Using a sandbag to weigh down the base of the stand or as a counterbalance on a boom will in most cases prevent a costly fall. Consider using a sandbag or similar weight on the tripod when the legs cannot be spread fully or if it needs to be tilted far to one side, as happens when shooting at a down angle and the legs have to be moved out of frame.

Other problems occur with stands on busy sets with numerous people buzzing around. Stylists and clients may run onto the set in a hurry, paying little attention to the stand legs underfoot. It is a genetic fact that stylists have big, clumsy feet and trip over every stand they get near, so tape down or weigh down any light stand in high-traffic areas. If it's not possible to do either, keep your eyes on the stands whenever people go onto set and be ready to jump to the rescue.

I used to work with a stylist who would trip over a light stand almost *every* time he went on set. After several diving catches of the strobes, I took to standing beside him and holding the stands as he passed. He didn't do it on purpose, but he was the clumsiest person I had ever met.

The same amount of attention is necessary for extension cords. Curl any excess lengths near the strobe pack or under the light stand to avoid anyone's feet from getting entangled. Cords that have to be stretched across areas where people are walking should be taped down flat to avoid tripping the unwary. The photographer and the assistant can usually navigate a tangle of cords without bringing the house down, but when other people are around it is best to prepare for the worst.

A crashing light stand makes a hell of a noise and may even create further damage to whatever it lands on. A broken strobe head can be repaired or replaced, but the subject or product on set may not be so easily substituted. Some items that are photographed are prototypes—none other exists—and a wise assistant takes extra care around irreplaceable objects such as these. Just the thought of the legal ramifications of models being injured on set is enough to give most photographers a heart attack. An assistant should secure the set against anything falling on the models or slipping out from under them, such as seamless paper or apple boxes used as platforms, by taping them down.

Preventing damage to equipment, or even larger disasters, starts with using only equipment that is in working order. Stands with missing or stripped knobs, or ones with sections that slip down, should not be used. Use stands that can be fully tightened to hold lights and other heavy objects first. If it should prove necessary later to use a defective stand, use it only for holding light items, like gobo cards. Any defective equipment, such as frayed electrical cords or strobes that give off a burning smell, should be marked and put aside for repair.

The name *hot light* should give assistants a clue as to why to be careful when working with tungsten lighting. These lights give off a tremendous amount of heat, and anything combustible that touches them runs the risk of igniting. Only heat-resistant gels should be placed in front of them, and then only with adequate ventilation. Space at the top edge of the gel should be left open to let rising hot air escape from behind the gel. Any fabric or background paper that gets too close to them may also burn.

Gels may also ignite or melt when attached to strobe heads if they are not adequately ventilated; after all, they are only heat-*resistant*. Curve the gels outward when attaching them to the strobes so that there is a slight bulge to the surface to ensure that the modeling light or flash tube does not touch them directly, and again leave the top open for ventilation. To ease the heat build-up behind the gels, keep the modeling lights turned off as much as possible. This will not only cool the lights off, but also prolong the life span of the gels, which will eventually discolor and crack from the heat.

People who claim that the light-diffusion material called Tough Spun will not ignite don't know what they are talking about. Once, several years ago, I trusted the photographer to help me set up the lights for an executive portrait, and I didn't watch him as he taped a piece of Tough Spun onto a strobe head. He didn't leave any room for ventilation, and I neglected to check his work. After four or five test pops of the strobe, the material burst into flames. As we tried to douse the fire, the Tough Spun flew apart into flaming tatters that we had to stomp out on the carpet. Luckily, none of the executives scheduled for the shoot had arrived yet, and we were able to open the windows to disperse the odor. When they did finally arrive, they were totally unaware that we had nearly burned down their executive conference room.

Booms have a way of causing a problem even if they don't fall on their own. While one end of the boom may be angled high over the set, the other end sticks out and is often low enough to be walked into by someone in a darkened studio. A piece of white or colored tape dangling from the offending end of the boom should be enough to make it visible and to warn anyone nearby to pass with care. That tape will save a lot of bumps on the head.

It's a good safety procedure to mark any sharp or hard-to-see object into which someone may walk with some light colored tape or to protect it with a larger, more easily seen object like an equipment case or a chair. Small bits of tape may be just enough to keep a person from poking an eye on the tip of an umbrella. You would be surprised how many times I've seen people do just that.

You can't keep the clumsiest people from bumping into things altogether, but you can avoid most accidents around the set by preparing for them. Eliminate the conditions that give rise to accidents, or at least minimize the damage that they may cause, whenever you can. When you can't, be ready to react and avert disaster. No matter how carefully you hand a photographer a lens, it still may get dropped, so be prepared to catch it.

Some accidents cannot be foreseen. A previously serviceable piece of equipment gives way, a person bumps into a clearly visible stand, or another act of God descends upon a shoot and bad things happen. Quick-witted assistants who are fast on their feet, though, can prevent the many unexpected accidents from becoming disasters. Unusual movement or sounds, like a shifting boom or a defective strobe pop,

may signal a problem; if you act upon it swiftly, you will minimize possible damage.

While I was working on a still life shoot, the sound of a tripod leg scraping along the floor attracted my attention. Since the photographer was at the very top of a six-foot tall ladder and resting much of his weight upon the tripod itself, the movement of the tripod was not a good sound. When I looked up from the tabletop, I saw the camera, tripod, ladder, and photographer all falling; the leg of the heavy-duty tripod had collapsed. Not only were they all coming down, but they also were falling directly onto me.

With one hand I caught the camera so that no damage was done to it. With the other hand I reached out for the photographer, keeping him from crashing straight into the floor. Though he still hit the floor, I was able to slow his descent enough to keep him from serious injury. Unfortunately, the photographer also grabbed for me and ripped my favorite T-shirt clean off my back. I had to finish the rest of the shoot looking like some reject from a professional wrestling match, but I had saved the day. Come to think of it, the photographer still hasn't replaced my shirt. I'm going to have to speak to him about that.

Another time, I caught an odd movement out of the corner of my eye. Looking in that direction, I saw an AutoPole that was holding the seamless paper backdrop start to slip. The photographer had forgotten to mention to me that one of the poles had lost tension and need to be repaired. I usually tilt these background poles very slightly away from set, so that if they fall, they fall away from the set. It was falling in the direction I had hoped it would, away from the set, but a falling roll of twelve foot seamless paper can still wreak havoc, so I grabbed the pole and managed to muscle it back into position before it fell completely. I called for help, and the photographer and I replaced the defective pole.

These are accidents for which you can't really plan; you just have to react to what is happening and trust to instinct. Assistants are not to blame for these freak accidents, but the ones who can move quickly to avert an unfolding disaster are more valuable to photographers than the ones who sit back and say, "Well, will you look at that," while they watch a stand fall. So, I say to all of you, stay on your toes.

Personal Safety

As assistants, we work in situations and with equipment that can be physically hazardous, and this job requires common sense and manual dexterity to avoid hurting ourselves while performing our duties. We handle high-voltage strobes and lighting equipment that can reach temperatures high enough to cause severe burns; we cut with sharp knives; and we climb tall, rickety ladders every day. Freelancers do all of this with a variety of systems and in different studios or locations, so they have to be even more cautious with the unfamiliar equipment and surroundings. Taking some precautions or developing safe procedures for yourself will prevent many of the injuries that can occur in this job. Knowing the dangers of the equipment that you are working with will also help you learn to handle it safely.

I feel like a mother telling you not to run around with the scissors. Unfortunately, I've had to learn a lot of these safety tips the hard way, but if they prevent you from cracking open your skull, so be it. Just call me mom.

The first safety lesson is to watch your head. From either bumping into low hanging objects or having things drop onto them, assistants receive a majority of their injuries to their heads. It is a temptation to rush and get chores done as quickly as possible to please the photographer. Unfortunately, this dashing around can lead to a throbbing bump on the head or worse. Believe me, I have the scars to prove it.

The low end of a lighting boom and the lead weight attached to it, as a counterbalance, is a magnet for an assistant's head. For some reason it is always the lead weight into which assistants knock their noodles. Every other part of the boom is made from lightweight metal and just a mere annoyance when bumped, but the weight is a fifteen-pound brick of solid lead that can leave an assistant seeing stars.

Avoid working or passing underneath booms whenever possible. Walk around them. If you do have to work underneath them, I suggest that you keep in mind the headache that you might get and move a little more cautiously.

When I first started assisting, I wanted to get everything done faster than other assistants did to prove my worth to the photographer. I zipped around the studio like a fool. The photographer asked for the hair light on the boom to be brought down a stop. I dashed over and changed the power setting, and stood up right into the boom weight. The boom stand teetered and nearly fell, and I was rewarded for my speedy assistance with a knot on the top of my head and a throbbing headache.

Speedy work and enthusiasm are commendable but not at the expense of causing damage to equipment or to you. Move around at a safe speed to reduce the risk of causing serious harm. You may still bump your head on things, but it will hurt a lot less.

What goes up must come down. Sometimes, they come down hard, and right on an assistant's head. Canvas backdrops and rolls of seamless paper are most often hung from crossbars suspended between two AutoPoles or other heavy-duty stands. These backdrops are very heavy when rolled up, and when they are mounted incorrectly, they may come crashing down. An assistant does not want to be directly under it when it does.

Ideally, the crossbar should be clamped at both ends to prevent either side from slipping free. The rolled backdrop should also be clamped to the crossbar to keep it from unrolling unexpectedly. Any adjustment to the supporting stands, up, down, or laterally, require small coordinated movements to maintain the balance. Because of the ever-present danger of a backdrop falling, the assistant should make these adjustments from any other side but the middle, under the crossbar.

You knew I had a story about a falling crossbar, didn't you? Well it wasn't *my* fault, but I was inexperienced enough to be right under the crossbar when it fell. Talk about learning a lesson the hard way.

Assisting a photographer during an instructional seminar at the big photo expo here in New York, another assistant and I mounted a large canvas backdrop onto two *high boys*, heavy-duty rolling stands. While I was unlocking the wheels on one stand, the other assistant unexpectedly moved the other stand. Since we hadn't clamped both sides of the crossbar yet, it slid free, and the whole rolled-up canvas dropped right onto my head, nearly knocking me unconscious. I fell, sprawling on the floor, dazed, in front of the entire audience. I don't know if it was the huge lump on my head or the humiliation of getting knocked flat in front of an entire crowd of my peers that taught me to stay out from under crossbars.

Don't leave tools on top of ladders. It is easy in the heated rush of a shoot to forget that you left a hammer on the top rung of a ladder until someone goes to move that ladder. The tool will fall directly down upon whoever is moving the ladder, and you hope it is not the photographer.

Not only does injuring ourselves on a job hurt physically, but it also damages our reputations. Photographers start seeing us as less of an asset to their business and more as a liability. Even though they carry insurance to cover such eventualities, none of them wants to risk having a clumsy or unlucky assistant around. All the hard work and dedication you put into assisting a photographer can go right out the window, along with your job, after a few too many mishaps.

Not too long after I started working with one photographer, for whom I was very keen on assisting, I was given the chore of sanding rust off some windows. I was left alone in the studio to finish the job before joining the rest of the crew on location. The windows were old-fashioned, industrial ones made of metal that tilted in, instead of sliding up and down. They were awkward to sand clean, and I frequently had to stop and readjust them.

Hurrying to finish the sanding so I could join the others on location, I stooped to retrieve the sander from the floor and raked my scalp along the sharp corner of one of the windows. Scalp wounds *gush* blood, and this one was no exception. With no one else around to help and feeling more than a little woozy, I sat down and tried to stop the bleeding, but to no avail. With no other choice, I notified the photographer what had happened, and set off for the nearest hospital to get the cut stitched up.

The timing couldn't have been worse. I was getting married in five days, and my fiancée was furious with me for not being more careful. It took five stitches to close the gash in my head. The doctor took pity on me by not shaving part of my head so I would not look like a weirdo in my wedding pictures.

When the stitches were in, I joined the crew on location and worked the rest of the shoot like nothing had happened, trying to salvage my reputation with this photographer. Unfortunately, the photographer was wary about working with assistants prone to such accidents, so it was a long time before she hired me again. Once the memory of that accident had faded, we began working together again, and she has since been very helpful to my career both as an assistant and as a photographer.

Not only do assistants have to protect their heads, but they also have to watch their step. Apart from the obvious need to step carefully around light stands and tangles of electrical cords, there are many other dangers for the less sure-footed. Climbing and crawling around on precarious perches are parts of assisting; it's not all done on firm, flat ground. Assistants may be asked to climb tall ladders, tread narrow catwalks, or work near dangerous equipment on locations, such as those found in factories. They need to know the limitations of their dexterity and to compensate for those limitations to remain safe on the job. Unlike cats, we don't always land on our feet. Photographers are not impressed with how quickly an assistant completed a rigging job if that assistant breaks bones doing it.

I have worked in many studios where the only ladder available was a rickety old wooden one that I wouldn't trick an enemy into climbing. If a ladder is unstable, use common sense, and have someone steady it for you while you are on it. Don't be macho.

Another temptation while at the top of a ladder is to reach too far to the side, rather than waste time climbing down and moving the ladder.

This is just plain foolhardiness. It only takes a few seconds to shift the ladder into a safer position to do the work, and it will save you the pain and embarrassment of tipping over. You may think I'm overdoing it a bit by warning you about this, but I have seen other assistants wobbling on top of ladders, and have known photographers not to hire them again because of their recklessness.

There are times when ladders will simply not fit into tight areas on set. A cluttered studio may also make it too difficult to pull a ladder out of storage. When using a ladder is not possible, or time constraints require a speedier option, some assistants use one or more apple boxes piled on top of each other to climb upon, to reach whatever it is they need to reach.

There is nothing wrong with using these boxes to do this; that's part of why they are there. But don't try this yourself, unless you are reasonably certain of your balance. Keep your weight near the center of the box to avoid it shifting under you; they weren't designed to hold someone doing acrobatics. Since they are narrow, they have a tendency to roll onto their sides.

Once we are out of the familiar surroundings of the studio, where we put our feet becomes even more important. Often we have to climb onto things that weren't meant to hold a person, like walls or platforms. It is in these situations that we have to watch our footing very carefully and sometimes test the surface before we put our whole weight onto it to avoid falling on our butts. We hope that all that happens from a fall is a bruised butt—and ego. Not paying attention to tripping hazards can result in far worse, however, like broken bones.

One daring photographer whom I know perched himself on a stone chimney to get the angle he needed. When he shifted his weight, one of the stones broke loose, sending him sliding down the roof to the balcony below. He considers himself lucky to have walked away with two broken bones in his hand. A lesson to the daring: your balance may be perfect, but it won't help you if the ground isn't solid.

Another photographer for whom I work was so engrossed in getting just the right framing for his shot that he didn't pay attention to what was on the ground around him. When he stepped back to get just a little more in frame, he tripped over an airplane tow bar. I was too far away to do anything but watch him tumble backwards. From the ground he found the perfect angle, but it cost him a broken leg. Since this happened on location in another state, I had the unique experience of having to push him through the airport in a wheelchair *and* pull the equipment cart. I think he still believes I bumped his wheelchair into all those corners at the airport just to torture him. Well, maybe just once.

These last two examples were photographers, but they easily could have been assistants. I know that *I* have pulled some stunts that could easily have put me into a hospital bed in traction, but I've always liked climbing things and am usually pretty cautious when I do take risks. Even a sure-footed person such as myself can be fooled from time to time into taking a wrong step. I could have sworn I was stepping onto solid ground when I plunged into that cement pit that I told you about earlier.

Taking simple precautions before acting can further reduce the risk of accidents. Knowing what the dangers are with certain equipment or working in unique conditions is the first step. Sticking with those precautions is the second. It may seem quicker and easier to ignore safety protocols, but you'll be glad you stuck with them should something unforeseen happens.

What should you be wearing when you adjust hot lights? Gloves. In my early days as an assistant, I worked with tungsten hot lights quite a bit. I burned my fingers so regularly that, had I been a criminal, the FBI would never have been able to catch me by tracing my ever-changing fingerprints. The barn doors that photographers attach to the front of these lights to shape the light beam are metal and get extremely hot. Sometimes through carelessness, and at other times from being too stubborn to get a pair of gloves, I would open or close these barn doors with my bare hands, thinking that if I did it quickly I wouldn't get burned.

Wrong. These lights get very hot and will burn you every time. When adjusting the barn doors, use a glove or a wadded-up towel to protect your fingers. The lights also take a long time to cool once they are switched off, so when the shoot is done, plan to turn them off first and put them away last.

Aerial photography is one of the more exciting parts of the business. Shooting from a helicopter over a site is exhilarating, but also potentially dangerous. They put seatbelts and safety harnesses into them for a reason. When the doorway is open, so that the photographer can shoot with an unobstructed view, the chance that something or someone could fall out is always there.

Even though the photographer is out on the landing skid safely strapped into a harness, and you are well inside the body of the aircraft, you should still be strapped in by at least a seatbelt when the door is open. The helicopter may maneuver radically to help the photographer get into the right position to shoot with no warning to you. Resist the temptation to unstrap so you can move more freely. If it is difficult to reach the photographer with equipment, loosen your belt, but never undo it. It's a long way to the ground.

On one particular shoot from a helicopter, the photographer asked that I take some wide-angle production shots of him out on the skid. To do that I had to lie on the back seat of the helicopter with my head out of the door. I strapped myself in and stuck my head out. It was exhilarating.

Because my earphones wouldn't reach, I had them off, so I didn't hear the photographer ask the pilot to fly in a tight orbit. That maneuver is a tight turn in which the helicopter is nearly on its side. Without knowing that turn was coming, I suddenly found myself upside down and spinning around. Talk about feeling airsick. I would have been in serious jeopardy, though, had I not taken the simple precaution of strapping in.

You may not always be in a position to know the safety protocol of a location before you get there. If something looks dangerous to you, ask for tips from the people who work on site. This is smart in any case. It's the difference between theory and practice. Those who do something every day are better instructors than people who just repeat what they heard from someone else.

For example, while shooting in a skyscraper under construction, I anticipated that the photographer and I would be shooting on higher levels that were unfinished and little more than bare girders, so I asked a worker how to walk "high steel." He was more than happy to teach me how to walk an I-beam. They are called I-beams because that is their shape when looked at from one end: two horizontal plates with a vertical one between them. He told me that only a fool walks on top of a beam, and that the safest way was to wrap my legs around the beam and place my feet on the lower surface of the "I," keeping inward pressure with my legs to steady myself.

It was a wild experience walking along one of these beams thirty-six stories up in the air with nothing beneath me for a hundred feet. Halfway across one beam a very stiff wind arose that would have seriously challenged my balance had I not been walking the safest way, as I had been recently taught. The photographer was less sure of his footing so he wisely chose to slide along the beams on his butt, holding on with legs and hands.

Walking high steel and shooting from helicopters are extreme examples, I agree, but getting into the habit of being careful on all jobs will allow you to work these radical shoots more safely. Photographers will also place more trust in you when they see that you are safety-conscious. Be a daredevil on your own time.

It helps many assistants to develop safety procedures that they use every time they do a particular job to avoid mistakes. No matter what equipment they are using, they stick to the way that they *know* is safest for them. These procedures may be a certain way they hold equipment, or unplug strobe lights, or use a mat knife. As long as assistants don't hurt the gear or themselves by handling it their way, it's best for them to do it in a manner that is comfortable for them.

I am very comfortable working with knives, and I cut showcards in a way that makes most photographers flinch. To date I have not drawn any blood, but I have come close once or twice. Instead of telling you how I cut these boards, I'll explain a safer way to do it.

Since most other assistants are not as sure as I am with using the sharp blades of a mat knife, I would suggest that they use a different method than the one I use. Lay the card down on a cutting surface, either a cutting board or another card, to keep the blade tip from penetrating the board and scratching the floor or table beneath. Place one hand on the board, away from the cutting area, to steady it and to avoid nicking any fingers with the knife, and make several shallow cuts until the blade penetrates the board. This will give you a nice clean edge and prevent you from cutting off any fingers.

In a rush to get things done, assistants often lift heavy objects the wrong way—with their backs instead of their legs. Most assistants are young and strong, and don't give much thought to how to lift heavy cases and equipment. But they don't stay feeling young and strong for long if they use their backs to lift. This job is punishing on back muscles, and too many assistants wake up in the morning wondering why their backs hurt at the tender age of twenty-two.

Lifting with your legs, while keeping your back straight, will take the strain off of your back muscles. The leg muscles are stronger than those in the back are anyway. You have your whole lives to develop back pain, so don't rush things by lifting the wrong way. I write this as I stretch my own aching back.

Electrical Safety

Freelance assistants are encumbered by working with a wide variety of different strobe systems, often in various stages of disrepair. Apart from knowing the many unique controls of each system, freelancers have to be aware of the separate safety procedures for using them all. Some manufacturers design strobes to be almost foolproof, but others only *claim* that they are. Even when the strobes are designed not to do certain things, like arcing, damage to parts of them may cause them to malfunction with disastrous results. Because freelancers work with different systems in rapid succession, many choose to use the strictest safety procedures of one system for all strobes, to avoid confusion in the heat

of the moment and making an error that could result in very serious burns. It's best to use strobes in the manner recommended by the manufacturer, but when in doubt, err on the side of caution.

Strobes are dangerous because they hold a tremendous amount of electricity that can be discharged in an instant. You don't want to be on the wrong end of that burst, so I suggest strongly that you use all necessary caution when working with them.

Now, I bet you are all asking yourselves, "How do I use strobes then, without getting fried?" Good question. Since you brought it up, let me pass along a few safety tips that I got from my friend Dave, who is the general manager of a leading strobe retailer and repair shop here in New York. I asked Dave some questions recently, because there are some procedures that I have used for so long that I had forgotten *why* I used them. He also debunked a myth or two for me that I had believed for years, just because one photographer had told me it was so. I'm not entirely ready to give them up, yet, so I'll file it under, "It could happen."

The largest danger a strobe poses to an assistant is *arcing*. Arcing occurs when the cord that attaches the strobe head to the power pack is removed from or plugged into a charged pack. The electricity stored in the pack leaps across, or arcs, the intervening space to the cord plug, causing serious damage to the pack, the cord, and the hand holding the cord. It's a nasty looking mess.

Earlier models of strobes, many of which are still in use in studios, were not arc-proof. Any time someone plugged a head into a pack that was on, it would cause an arc. Since then, the manufacturers have designed arc-proof or arc-resistant models that are supposed to prevent foolish users from arcing the pack, and allow cords to be plugged into the pack while it is on. In theory, they work. In practice, the story is a little different. All it takes to arc an arc-proof pack is a little damage to the pins in the plug on the head cord. The arcs may not be severe, but it is not good for the equipment and more than a little frightening to the person plugging in the head.

The least arc-resistant packs and older units need to have their charge *dumped* before a head can be removed or added. This is done by switching the power pack off and then quickly popping the strobe. Once the pack has been fired it is safe to add or remove heads. Another way to render a pack safe is to turn the power off and wait for two minutes or more to make the switch; the charge bleeds off slowly and eventually it is safe.

Unless I am fully aware of the operational condition of a strobe unit, I treat them *all* like they might arc on me. I'd rather be told regularly by a photographer that I don't have to dump the pack, than risk getting my hand blown off by a pack that malfunctioned.

Some strobe systems use light cords that detach from the strobe heads as well as the packs for easier transportation, as seen in Figure 8–1. The small length of cord that emerges from the head is called a pigtail, and the cord that runs from there to the pack is called the head extension cord. *Always, always, always* attach the head extension to the pigtail first, before you plug into the pack. Work from the strobe head down to the pack. The pigtail connection is not arc-proof when the head extension is already plugged into the pack. Even if the pack is off, there may be enough residual charge to arc at the pigtail.

I have also been informed by Dave that there is a slight chance of a mild electrical shock from touching the pack and head at the same time. In effect, your body is completing the circuit. Another risk is to hold a stand when the strobe is fired. I'm no electrician, so when someone warns me about "slight chances," I listen.

The worst electrical shock I ever got was when I plugged a defective power cord into a wall socket. I heard a loud bang and the next thing I knew I was sitting on the floor in the middle of the room. Half of the power in that old building shorted out as well. After that, I've had a healthy respect for the dangers of electricity.

Strobe tubes have been known to explode into shards of glass from time to time. There are stories floating around of a model who caught one such explosion square in the face. Whether or not that story is true, it is probably not wise to put your face too close to a firing strobe. The powerful burst of light alone will have you seeing spots for hours. Work from behind or to the side of a strobe head unless it is turned off; you never know when someone may fire it accidentally.

Tungsten bulbs, strobe tubes, and modeling lights do not react well to the oil from our skin. The glass of the bulb will start to bubble as it heats up and eventually it will blow. Never touch a bulb with your bare hands; use a glove or paper towel to hold the bulb when you replace it to avoid transferring skin oils onto the glass.

Water and electricity don't mix. Any time you are using electrical equipment around water you have to proceed with extreme caution. Water has to be kept away from the gear, and the gear has to be secured from falling into the water. Most of you are probably saying, "Well, duh!" but it bears mentioning.

Whenever you are using lighting equipment around bodies of water, you have to weight down every stand to keep them from tipping over or getting bumped into the water. Use more sandbags than you think are necessary. You want the stands to be immovable objects. I would imagine that a strobe falling into the water would prove fatal to anyone *in* the water at the time.

Similar precautions should also be taken for power packs and cords near water. Cords and packs should be kept dry at all times and should be kept off even damp ground. This is another place where attaching dog collars to the power packs comes in handy; they can be hung from the light stands to add stability to the stand and keep the pack and cords above any dampness. If extension cords need to be run through mildly damp areas, such as wet grass, tape plastic around any connections to avoid shorting out the power.

I worked a shoot once that was around an indoor swimming pool. We put three sandbags on every light stand, and since the floor was wet we hung the packs from the stands and gaffer taped all the cords to the tile walls. Everyone on the crew was instructed to move very carefully around the lights, but wouldn't you know it, a stylist still tripped over a stand leg. With forty-five pounds of sand on all of them, the stand wasn't going anywhere, but we all held our breaths for what seemed like minutes.

Another danger to strobes outside is rain. At the first sign of raindrops, turn the packs off and unplug them. Get all the strobe and camera gear under cover immediately—and hope that everyone in the crew will grab a piece of equipment. The strobes in a light rain might not electrocute you, but they don't react well to raindrops in the power sockets.

An assistant who is aware of the pitfalls of working a set and who takes steps to reduce their number and the severity of damage that they can cause is valuable to every photographer. Photographers want assistants who not only look out for the studio's reputation, but also for the safety of everyone and everything there. By reducing a photographer's liabilities, the assistant becomes a greater asset.

Assistants may want to impress their photographers by taking risks to get the job done better or faster, but in the end, assistants have to take care of themselves. No matter how well assistants perform, there is no guarantee that the photographer will ever hire them again, so all the crazy risks taken on the photographer's behalf will have been for naught. If assistants get laid up with a serious injury, they can't be out making a living—no work, no pay. Good assistants look out for the safety of the equipment, the crew, but most of all for themselves.

Figure 8–1 Make this connecton before plugging into a power pack.

9

Tips and Tricks

Now let's get to the good stuff. This chapter is full of all the little tidbits that I have picked up along the way during my twelve years as an assistant. None of these tips warranted a chapter all to themselves, but they are valuable nonetheless, so I piled them all into one. These aren't things you can learn in school, and my seminars aren't long enough to include all of them—even though this is the stuff the audience likes to hear most.

The tips and tidbits are laid out in categories that are arranged alphabetically to help you refer to them more easily. If you do not recognize a term or a piece of equipment, check the Glossary at the end of the book.

Accidents

Eventually every assistant will experience an embarrassing or disastrous moment and would like nothing better than to crawl away somewhere and die. If an assistant works long enough, something bad is bound to happen. Work harder than before to make up for your mistakes if you have to, but don't worry about it too much. All things pass.

A few years ago, several of my assistant friends shared with me stories of their most embarrassing moments. Here is a list of the top ten.

1. I sideswiped a truck with the rental van, cutting a gash clean through the side panel of the van. I'm now, laughingly, known as "The Captain of the Titanic" in that studio.

2. I stepped off a catwalk straight into a pit of wet cement. When the photographer realized I wasn't holding any shot film, he left me there.

3. While swinging around an AutoPole in a fashion showroom, I broke an expensive lamp. Luckily the client wasn't too upset.

4. Touching up the paint on the wall of an intricate room set, I dropped the paint can and spilled a whole gallon of blue paint on the carpet. I thought I was done for, but the photographer was cool about it. We shifted the stained portion of the carpet underneath the wall of the set, hiding it.

5. I confused two packages and sent unexposed film to the client and the processed film back to the lab. It took a while, but eventually we sorted it out.

6. Working around the studio, I gashed my head open and it required five stitches to close. Talk about looking clumsy!

7. I have a nickname at one studio. They call me "Crash," because of my tendency to bump into things with the rental van. (Another van accident; there must be a lot of defective rental vans out there.)

8. I blushed beet-red on my first shoot with a nude model, and everyone laughed at me.

9. I once radioed the photographer, who was scouting a building at the time, to tell him that I had to leave the car to find a bathroom (those weren't my exact words). I was answered with hysterical laughter from a dozen voices. Apparently the photographer was in a crowded elevator at the time I called.

10. The most humiliating story I have ever heard an assistant tell was this one. After getting food poisoning on a flight to England, I vomited at the client's feet, nearly splashing him in the process.

Why did I list all of these humiliating stories? Well, I just wanted you to know that everyone screws up, sometimes in a big way. If you have developed a reputation for yourself as a good assistant, you can live down the most embarrassing mistakes. All of the assistants from the above list eventually went on to become successful assistants and photographers. By the way, half of those stories are mine.

Airports

Dealing with airports is probably the most difficult part of traveling on a photo shoot. From getting the gear out onto the curb before departure, to loading up the rental car at the other end, it is one hassle after another. After you've done it a few times, you learn there are things that you can do to make the trip easier and minimize the chances of having a problem, or you can just read the tips below and save yourself months of practice.

The first thing to prepare for is the limit on baggage, both in number allowed and size. Airlines differ in the number of checked bags that they allow; generally, it is two bags per person for coach passengers—three if you are in first class. Each bag should be seventy pounds or less to avoid overweight charges. Each passenger is allowed two carry-on items; a folding luggage cart is now counted as one carry-on item. Airlines are also enforcing their size limitations for carry-on more strictly than before; the size limit for most is 14" × 22" × 9". Some airlines require that you *prove* your bags conform by shoving them into a sample frame at the gate.

Have you got an extra bag or two and some of them are overweight? You can often get around that by doing curbside check-in. Nonchalantly keep a couple of tens in your hand when you hand your ticket to the skycap; this lets him know you're a good tipper. To get the good tip, he may wink at your extra bags, but if he doesn't only give him one ten. As the assistant, you will be helping him load his cart with the gear. If you have any overweight cases, hand the skycap a light one while you load the heavy one. That way he never feels the weight of it. You've got to be cool about doing this, though; don't groan while lifting the case. This only works on a small scale. If your photographer flies with the whole studio packed up, you're going to get stuck with excess charges.

While you are checking in ask the skycap if there are any earlier flights scheduled to your destination. Some airlines have numerous flights per day to certain destinations, like Delta Airlines from New York to Atlanta. If there is an earlier flight tell the skycap *not* to "advance the baggage." You want all the bags to be on your flight, so that they arrive when and where you do. It is easy to walk off with bags at many airports, so you do not want them sitting around baggage claim for any longer than necessary.

One last curbside tip. If you have more than one luggage cart, tape them together with gaffer tape so that they only count as one item. This is a good reason to keep a bit of tape in your pocket. It'll save the photographer a couple of bucks.

You've got the bags checked. Now what? The security gate. This is another danger spot for the film and camera equipment. The x-ray machine and metal detectors are areas that airport thieves use to separate you from your valuables. After your carry-on bags have been placed on the belt, one of them slips in front of you in line and gets stopped at the metal detector, keeping you from catching up to your bags. While the first one delays you, another thief picks up your case on the far side and walks away.

To prevent this from happening, send the photographer through first, so the gear can be protected on the other side of the x-ray. Once the photographer is through, put the gear on the conveyor belt. Request that the film be hand-checked by the security officer. Even though they might argue that the film is safe, any exposure to x-rays does affect it. If you are going through multiple airports on your trip, the exposure to x-rays is cumulative and will start to fog the film. Lead film bags provide *some* protection, but security personnel will just turn up the power to see through the bag, still zapping the film.

I keep all items that might set off the metal detector in my shoot vest that I wear while traveling; that way I am never delayed while going through. I want to be physically separated from the gear as little as possible. The shoot vest gets put on the x-ray belt with all of the other gear.

Most times security will want to open the camera cases to have a look inside. Now, you really don't want the entire airport seeing the valuable camera equipment that you are carrying in an easily stolen case, so you are allowed to request that the cases be opened in a secure place, usually a room or curtained area. If you are running to catch your flight and do not have time for this, use your body to block the view of other passengers. Keep all the bags for which you are responsible with you at all times. Don't trust that security or the photographer will watch them; they are preoccupied with other things. Before you leave the security gate make sure both you *and* the photographer have everything, especially the shot film.

Some photographers prefer to hold onto all the airline tickets, so they always know where they are. If you are holding your own tickets, always put them in the same place, so you can keep track of them. It's really embarrassing to get to the boarding gate and not know where your ticket is. Pick a secure pocket and use it to store your tickets and other important paperwork every time you fly.

Airports are crazy, confusing places with many people running around and bumping into you, so keep a sharp eye out for anyone getting too close to the gear. The gear should be within reach at all times. Stay in physical contact with the gear whenever you are not pulling it around the airport. Drape a leg over it while sitting at the gate, in case reading or talking with someone distracts you.

While you are waiting to board the plane, watch out the window to confirm that they load all of the equipment and suitcases onto the plane. If they haven't loaded the baggage by the time you board try to watch out a plane window. One thing you may see is rough handling of the equipment cases. Report anything that might have caused damage to the gear, or any cases left on the tarmac, to the photographer.

Very often we have more carry-on bags than the airline allows. One reason that I wear the shoot vest when I travel is to shove all the little bits of gear that I can into the pockets to reduce the size of carry-on bags, but sometimes that is not enough and we have extra. When I need to get that additional shoulder bag onto the plane, I carry two bags on the shoulder opposite the ticket taker, with my jacket draped across them to hide the number of bags on my shoulder. I haven't been stopped yet.

Get your butt into your seat as quickly as possible, and stay there in case the airline has double booked it. As polite as you like to be, if someone else shows up with the same seat assignment as you do, stay in the seat. Have the other person straighten it out with the steward. Once your butt is in that seat, the airline can't make you give it up, and you *have* to arrive with the photographer and the gear.

Upon arriving at your destination, get to baggage claim as quickly as possible. You don't want the cases coming out without your being there to watch over them. Should you be traveling with large or heavy cases, look around for the "Oversized Baggage Claim Area." Most airports have special areas for big bags and yours might just pop out there.

Now that you have all of the cases, you have to get them out to the curb and wait for a cab or the photographer to pull up with the rental car. Pile the gear in one area and stand so you can watch for the car while keeping the gear *directly* in your sight. Make it as difficult as possible for anyone to walk off with one of them.

All of this may seem paranoid, but I have never had a case not make it. So many things can happen at airports that you have to be a bit paranoid to protect everything. Thieves count on the confusion air travel causes to make off with valuables. Don't trust anyone.

AutoPoles

- To make a background stand you will need two AutoPoles, two super-clamps, two J-hooks, and a crossbar. Place the AutoPoles slightly wider apart than the width of the backdrop. Attach the super-clamps at the desired height and insert the J-hooks into them. Slide the crossbar through the rolled backdrop and cradle both ends into the J-hooks, and voilà, you have a background stand.

- Use medium-sized A-clamps to hold the crossbar to the J-hooks. Use another medium A-clamp to hold the backdrop to the crossbar and wedge that clamp against the clamp holding the J-hook to keep the backdrop or seamless paper from unrolling.
- Make sure AutoPoles are locked down and tight between the floor and ceiling. Give them a wiggle to confirm a tight grip. Check that the ceiling is solid before you press against it; drop ceilings will not hold an AutoPole for long.
- Slip plastic baggies over the rubber tips on the AutoPoles to keep them from leaving little black rings on the ceiling.
- Use a window frame or other straight line to visually level the AutoPoles. They should be perfectly vertical.
- Don't attach other clamps too tightly to AutoPoles. They are hollow and dent easily; a super-clamp can severely damage AutoPoles.
- Finally, watch your head when under the crossbar. A canvas backdrop falling from twelve feet can leave a big dent in your head.

Black Shower Curtains

These are great all-purpose items to bring with you on location. You can use them for blocking window light; as ground cloths to lay on wet ground to protect equipment or the photographer's clothing; to protect tabletops; or to hide equipment from prying eyes in cars. They are easily folded and light enough to carry several with you on location.

Broken Equipment

Whenever a piece of equipment breaks down, put a length of white tape around it to mark it as broken. When you are working with several identical pieces of equipment, it is easy to forget which one is in need of repair, so mark it right away.

If the photographer does not have a repair log, make one. List each piece of damaged equipment by type and serial number, date of problem, description of problem, date repaired, and description of repair.

Bungee Cords

These rubbery cords are great for securing cases to luggage carts or hand trucks. They are also handy for lashing stands to objects for stability.

Cabs

As assistants, we spend a lot of time in taxicabs, so you wouldn't be the first to leave something in one. Check around the seat and trunk to ensure that you have everything before letting the cab go.

Cameras

- Before loading cameras, check for dust inside or hairs between the shutter and the mirror. Take the lens off and set the shutter on the B setting. Hold the shutter release button down, hold it up to a light, and remove any hair or fluff that is visible.

- Never hand a photographer a lens with dust or fingerprints on it. The photographer may not see the dirt until the film comes back with spots. Use lens tissue and fluid or a special lens cloth to clean smudges off the delicate surfaces of a lens.
- Keep your hands away from the glass of lenses or you will spend much of your time cleaning fingerprints.
- Don't take it for granted that a photographer has prepped a new piece of equipment for use. I once had a photographer hand me a new camera body and tell me to load it. Assuming that he had checked it out, I loaded it and used it for half of the shoot. Only later did we discover that a piece of plastic used in shipping had been left in the camera, in an area that my right hand covered while loading, so I never saw it. This plastic scratched all of the film, making it useless. Though the photographer mercifully never placed blame, it was completely my fault; I should have checked the body over completely. It only goes to show you that even experienced assistants screw up.
- Check new equipment for—and remove—all packing materials.
- Alternate camera bodies (if there is more than one) throughout the shoot, in case one malfunctions.
- A location assistant's day ends with cleaning the day's dirt and dust off cameras and lenses.
- Check the batteries in cameras occasionally to see if they are fresh.
- Mamiya 6 × 7 lenses have a lever that closes the shutter in them. Make sure the lever is open before mounting the lens.
- Know where camera equipment is at all times, and where each piece is located in the case so you can retrieve it quickly.
- When working outside in the cold, do not open the camera or film back with gloves on your hands; the fluff may get inside. Wipe your hands to get any dirt off of them before handling an open camera.
- Keep camera cases closed when on location in a dirty environment to prevent dust from accumulating inside the case.
- If your photographer has a tendency to accidentally change aperture settings while shooting, tape the aperture ring down.
- If your photographers want you to bracket the lens while they are shooting, call out the f-stop numbers so the photographers know where in the bracket they are.
- Remember original settings when you are asked to change them; photographers are notorious for wanting to change them back.
- When photographers are climbing or descending a ladder, hold the camera for them so they can climb with both hands. It'll save you having to make a diving catch when they drop it.
- Let the photographer lift the camera equipment out of your hands when passing equipment back and forth. Don't let go until you feel it pulled from your grasp.
- Camera equipment needs time to acclimate to changes in temperature and humidity to avoid fogging over. Going from an air-conditioned room or car to hot, humid summer weather will fog gear as soon as the case is opened. Keep the camera case closed and place it in direct sunlight to slowly allow the temperature inside to equalize. If equipment does fog, go to the car and turn on the air-conditioning and the heat at the same time and put the equipment directly in front of the vent. The heat brings the gear up to temperature and the air-conditioning dries the air out. This will defog the gear quickly.
- Use your body to shade the camera when you are loading it in the sun. This goes for film backs too.

- If the camera is sitting in the sun for a long time—when you are waiting for the makeup stylist to finish working on the model, for instance—drape a towel over the camera to keep it cool. Be careful not to get any fluff from the towel on the front of the lens.
- Put away camera gear first when a shoot is done. You risk knocking over the tripod when moving around bulky set equipment.

Canned Air

Need to remove a blob of hot glue or a wad of chewing gum from your shoe? Flip a can of Dust-Off upside down and spray it on dried glue, as shown in Figure 9–1. The propellant in this product will shoot out and freeze anything it touches, making the glue brittle; then you can just peel it off. This process also works to speed the cooling of freshly applied hot glue.

Be careful when spraying canned air in this fashion. The propellant is very cold; keep your hands away from your target.

Cases

- Zip cases up slowly. The corners of zippered cases are vulnerable to tearing and distortion of the zipper.
- Lift cases by both handles to avoid ripping the threads attaching the straps to the case.
- Look for gouges or tears in the cases to warn you of rough handling by baggage handlers at the airport. Marks on the case may indicate damage to the gear inside.
- Lift strobe cases with your legs, not your back, to avoid strain. Lifting heavy cases out of a car trunk is hard on the back muscles, so don't jerk the case up.

Figure 9–1 Time to remove the hot glue holding this armature wire to the doll.

Cinefoil

- This heavyweight black foil is easier to carry on location than solid snoots. Use it to shape directional light sources.
- Under the intense heat of hot lights, Cinefoil may smoke a bit. This is harmless, unless it is under a smoke detector or sprinkler.
- Use bits of foil to black out light fixtures that won't turn off, but leave room for ventilation, if possible.
- Be careful handling Cinefoil when it is mounted on hot lights. It is a metal, after all, and can get very hot.

Cords

- If you want to hear a photographer scream, coil extension and strobe cords around your elbow. This is a pet peeve of most photographers. Curling cords around your elbow turns them into twisted spaghetti. Loop them in small circles. Cords will find their own proper coil size without twisting, as in Figure 9–2.
- Use the little packaged towelettes from restaurants and airplane bathrooms to wipe cords clean.
- Coil excess cording under stands to avoid tripping over them.
- Tape cords flat in high-traffic areas. When removing them, lift tape up first instead of pulling the tape up by lifting the cord. If you lift tape up by the cord, it will stick to itself. Once gaffer tape sticks to itself, it is hard to pull it apart.
- Separate cords so that they do not cross. This way you can keep track of where each cord leads.

Downtime

Use your downtime constructively. It makes you look better to your photographers, and you can get chores done to make the end of your day shorter. In between shots you can put away unused equipment or clean.

Figure 9–2 The proper way to coil cords.

Driving

Most drivers don't like to be told how to drive, but take this bit of advice: don't drive while sleepy. If you are driving long distances with a photographer, load up on caffeine. Pull off the road the moment that you feel groggy. The line between feeling sleepy and falling asleep is very narrow, so don't push it.

Famous People

Play it cool around famous people. It's very exciting to work with the glitterati, but try not to grovel. Be competent, pleasant, and professional. In my career I have shot or assisted on shoots of Arnold Palmer, Henry Kissinger, David Letterman, Tony Bennett, Richard Belzer, Anita Baker, Sam Waterston, Quincy Jones, Robin Quivers, Steven Stills, Graham Nash, Cyrus Chestnut, Dr. Ruth, Geena Davis, Shaquille O'Neal, Michael Douglas, Butch Harmon, Nancy Lopez, and Gilbert Godfrey.

Fill Cards

If you don't have room to spread the legs of a stand on a set to mount a fill card, or reflector, put up an AutoPole and clamp the card to it. Another trick for holding a four-by-eight-foot foamcore is to invert a J-hook and mount it to an AutoPole. Slip the foamcore under the hook; the J-hook and AutoPole will keep the card in place, but allow free movement of angle.

Film

- Keep film shaded from bright light. When handing film to a photographer in the sunlight, cup it in your hand with your palm facing the ground.
- When loading roll film—120 and 220 film—be sure to remove the entire paper ring that seals an unexposed roll of film to prevent pieces of it from lodging in the back of the camera.
- Don't leave the film in the car. The heat that can build up in the car can adversely affect the film.
- Know where the shot film is at all times.
- Label the film clearly. Each roll has to be marked and listed on the film notes, so the photographer will know how to process it. Write six and nine like this: 6 and 9.
- Don't throw out the opened boxes from 120 film. Take the empty boxes of twenty rolls of film and tape them together with the open ends all facing one way, as shown in Figure 9–3. Placing shot film back into the boxes keeps it organized and protected.

Film Backs

- Lay film backs out on the set cart, so that you and the photographer can readily identify which backs are loaded and which are empty. Loaded film backs should be arranged right side up, with the dark slide face down. Empty or exposed backs should be placed with the dark slide face up. This procedure is fairly standard in the industry.
- Check regularly for dust.

- Any time you can't find the dark slide, check the photographer's pockets. Come to think of it, check the photographer's pockets every time things like dark slides or lens caps can't be found.
- Keep accurate film notes of every shoot. Make notes of changes to the image itself, as well as exposure, lenses, filters used, and processing directions—such as push $+\frac{1}{2}$ or clip. When handling over 350 rolls, it gets difficult to remember details unless they are written in the film notes.

Flex Fills

- These are very hard to hold still in the wind. Hold them in both hands and use your chin to steady the top.
- Every movement of the Flex Fill changes the meter reading on the subject. If the model is not getting a full hit (the strongest amount of light possible) from the Flex Fill because the wind is knocking it around, let the photographer know.
- Having trouble folding them up? Don't worry, I know photographers who still can't do it. Hold the outer ring in both hands, one on each side. Position your hands with your palms facing each other, then twist the ring with your hands in opposite directions and it should fold up neatly. Try it a few times and you'll get the hang of it.

Fun-Tak

- This green goo sticks to just about anything, but leaves no residue when removed.
- It is useful for holding small fill cards, mirrors, and paper without damaging them.
- Stick a wad of it behind glass picture frames to tilt them to eliminate glare.

Figure 9–3 It's much easier to find a particular roll this way.

- Dab a wad of Fun-Tak on any tiny bits that are left attached to the surface when you remove the Fun-Tak; the wad will pick up any stuff left behind.

Gobos

- Use your own shadow to shade the lens when you can't set up a gobo card on a stand. This allows you free use of your hands to load film.
- Shade the photographer's eyes, too, if the sun is shining in them. If the photographer is cupping a hand around the camera eyepiece, it is a good indication that the sun is making it difficult to see through the camera.
- Strobe umbrellas make effective gobos to shade the lens and photographer when shooting in bright sunlight. Clamp the umbrella to a stand and weight the stand down with a sandbag.
- Check through the camera to confirm that gobos do not appear in the frame.
- To see if a gobo is effective, look at the front of the lens. If you can see the spots of light sources being reflected in the glass, adjust the position of the gobo until the spots disappear.
- When shooting a backlit subject outside, you may have to handhold a small gobo card above the lens to shade it. Concentrate on holding that card steady so it does not creep into the frame.

Grids and Barn Doors

- Be careful when handling grids and barn doors after they have been on the lights; they get very hot. Try not to melt your fingers.
- Attach any gels or diffusion materials to grids and barn doors with wooden, spring-loaded clothespins. Wooden clothespins do not heat up like metal A-clamps. Because grids and barn doors get so hot, any tape used to hold gels will melt. If you're lucky, the tape will just fall off, but sometimes it leaves behind a sticky goo that is hard to remove.

Grip Arms

Tighten the knob and then press down on the far end of the arm (as in Figure 9–4) the end upon which you will mount the light. If you can force it down more than an inch or two, you have the arm facing the wrong way. Loosen the knob and flip the arm over to the other side and retighten. When you have it on the correct side, the arm will tighten as you push down.

Kids

Many shoots involving children and babies will have a "wrangler" present. The wrangler is someone who handles and entertains the children and is skilled at eliciting the responses from the child that the photographer wants for the shot. Their shoot kit is a bag full of toys that they use to attract the child's attention toward the camera. Working with children is very hard; you never really know what will get the right response from them. You hope that they will be entranced by the wrangler long enough to get the job done.

Young children will often key off of one person in particular. When you're lucky, it's the wrangler, but sometimes it is the child's mother or even you. Watch their eyes to see who they look at most often.

Even though I work on many children's shoots, I'm not much of a "kid person." Their high-pitched squeals give me an instant headache. But for some reason, an occasional child will just fixate on *me*, and I am the only person in the crew who can get him or her to smile or laugh. When that happens, I move into the role of temporary wrangler. A funny voice, or the goofy laugh that I borrowed from one of my photographers, usually helps to get the kid to smile. Other times I have to become the "tickle monster" to get the kid happy. One thing I have found that works with most kids is telling them a secret and working with that. I tell them that the photographer has a "fuzzy pickle nose" and have the kid tease the photographer. They love it. Who knows why it works, but it does.

The mood of a child can change in a blink of an eye. If it is not working with you as wrangler, back off. Once the child is unhappy being on set, there is very little you can do to get the child to want to be there, so don't push.

Since a child's moods change so quickly, be prepared to "cover" the camera when the photographer steps away from the tripod. The perfect smile or expression may happen while the photographer is on set near the child, so you have to be ready to click the shutter. Check with your photographers to see if they want you to do this. Some get very huffy at the suggestion, but others welcome the help.

Knobs

- Tighten all knobs only as tightly as is necessary to hold firmly. They shouldn't be so tight that you need a wrench to undo them. Any more than finger-tight and you run the risk of stripping the screw.
- Remember—"Righty tighty, lefty loosey." This silly rhyme will help you remember which way to turn a knob to tighten or loosen it. Yeah,

Figure 9–4 Make sure grip arms are tight to avoid slippage.

it's an annoying expression, but I see plenty of assistants and photographers struggling with knobs, trying to turn them the wrong way.

Light Bank

- Leave a small space open in the back of the bank to vent hot air.
- Check any gels mounted on strobes inside a light bank occasionally to confirm that they are still attached. It is difficult to see that a gel has fallen off from the outside, so open the back up and check inside.
- Store unused banks in their bags to prevent the front panel from yellowing.
- Make sure the mounting ring is on the strobe head securely. A falling bank can damage a strobe head with an exposed tube.
- Set a heavy six-foot bank on the floor and mount the strobe head to it, rather than fitting the bank to a head already on a stand. This is easier than trying to hold the big thing steady while screwing it onto the head.
- Check the big ones occasionally to see if they have tilted under their own weight and are pointed at the ground instead of the subject.

Lighter Fluid

Did someone paste a label right onto your new portfolio case? Use lighter fluid to remove the goo left by sticky labels. It is safe to use on Plexiglas and even leather.

Luggage Carts

The vertical poles in lightweight luggage carts are susceptible to bending out of alignment when hauling heavy loads. Ease the pressure on them by lifting the cases with one hand while tipping the cart. Don't yank on the poles or you may find you can't close the cart when necessary.

Luggage Tags

Air travel is hard on equipment cases: surfaces get gouged, handles get broken, and nice leather nametags get ripped off. I learned this next trick just recently, and I think it's ingenious. It's so simple, I don't know why more people haven't thought of it.

Slip a length of brightly colored gaffer tape through a D-ring on each case; don't put it around a handle because a handle can get broken off. Press the sticky sides of the tape together—you know how hard that stuff is to pull apart when you do it by accident. Now, write the photographer's name, address, and phone number on the tape. Voilà, you have a luggage tag that won't come off. Because it is flexible, nothing can get caught on it, and the bright color will make the cases easier to spot on the baggage carousel.

Meter

- Each photographer meters a little differently from the next. If you are unsure how the photographer wants a reading done, ask. Generally, do a light reading with the meter pointing towards the lens.

- Tell the photographer exactly what the meter reads; don't round off the numbers.
- When shooting outside on days with scattered clouds, it can be difficult to keep up with the changing light. As the assistant you are often too busy or unable to run onto the set to take a light reading every five seconds, so to keep abreast of the changing exposure, take a benchmark reading. To do this, take an initial meter reading for the subject; this is the exposure to be set on the camera. Then, under the same lighting conditions, take a benchmark reading at your workstation. The benchmark reading is only to indicate changes in the original subject exposure; the actual f-stop number is irrelevant. Continue to take readings in that spot and call out the *changes* in light levels to the benchmark reading, such as down two-tenths or up a stop.
- When you are out of earshot of the photographer, indicate the exposure by holding up the appropriate number of fingers.

Modeling Lights

- Turn off modeling lights before moving a strobe more than a couple of inches. The bulbs have a tendency to blow out when bumped around, and they are very expensive to replace.
- Use gloves or a clean paper towel when handling the bulbs; oils from your skin make the glass bubble and eventually explode. Replace any distorted bulbs immediately, but wait until they cool before handling them.
- Some strobe systems allow you to control the modeling lights from the power pack. Switch modeling lights on and off from the pack when the heads are too high to reach.

Opportunities

Assisting is a great opportunity to meet people, go places, and experience things that you wouldn't have the chance to on your own. Don't be timid; grab the opportunities that come your way. You never know where they might lead you.

I once received a phone call from a photographer who shared studio space with one of my regulars and who was looking for an assistant. Even though I wasn't interested in taking on anyone new, I agreed to work with him. It turns out he specializes in golf landscape photography. I'm an avid golfer, and through working with this photographer, I have gotten to play some courses I otherwise would never have been allowed to play. Not all opportunities are photo-related.

Packing

Packing is an art. It may seem ridiculous to be teaching you how to pack, but it is necessary to pack the right way to avoid damage to the gear. Know how each item or case will react with its surroundings.

It helps to pack cases tightly to prevent anything from sliding around. Pack delicate objects in compartments separate from heavy or sharp items like strobe packs and clamps. Even though a case may survive a drop intact, the contents will crash against each other, so you want to keep them from bouncing around *inside* the case.

I remember the curses and grumbling from my father every summer as he tried to pack the luggage into the truck of the car for the family

vacation. He would pack and unpack numerous times to make everything fit in the trunk, but something always ended up broken by the end of the trip, having gotten squished by another case.

We, as assistants, don't have the luxury of letting equipment get damaged in the trunk. We have to be aware of how each case will react to the ones around it, not just if they will all fit. Be sure that the cases are flat up against each other to avoid the sharp corners of one from pressing into another.

Passport

Don't wait until you get called for that great international job to get your passport. Have an updated passport available at all times. Two great trips came to me because the photographer's other assistant didn't have a valid passport, and there wasn't time for him to get one. When photographers know you have travel experience, they are more comfortable calling you to help them on these trips. I have been hired to work shoots in England, Ireland, Canada, France, Turkey, Poland, Italy, Australia, New Zealand, Venezuela, Mexico, and Jamaica. I can't think of a better way to travel to foreign countries than to have someone else pay for it.

I've been to some great places in the United States as well, also on someone else's dime. I've done shoots in Miami, Los Angeles, San Francisco, Seattle, Atlanta, Dallas, Boston, Las Vegas, Lake Tahoe, Memphis, Chicago, and Colonial Williamsburg, to name a few. Many of these traveling photographers hire me because I have had experience traveling on shoots and know how to get gear through an airport.

Politics

Keep your mouth shut about other people's affairs. You have to watch what you say and to whom. You never know when something you say will come back to haunt you.

Portfolio Drop-Offs

Whenever dropping off a photographer's portfolio with an agency or magazine, get the name of the person you are handing the book to directly. Policy may require that you leave the portfolio in the office mailroom rather than hand it to a receptionist or art buyer, but never leave a portfolio on a counter unattended; physically hand it to someone and ask for his or her name. In case something happens later, you can say that you put it into this person's hands. Portfolios are precious; take care of them as if they were your own.

Priorities

On any assisting job you will have many things to accomplish. Arrange your tasks into an order of priority. Tackle the most important jobs first and then complete the others. Getting the gear in the right place at the right time and working in the proper way to get the shot are your first priorities. Fine-tuning an image is secondary for you. When those priorities are out of the way, you can attend to your other duties, like servicing the client, cleaning, and so forth.

In our drive to make an image *perfect*, we often worry about the small details, things that may not even appear in the final image or affect it at all. One of my photographers has an expression for these unimportant details. He calls them "a BB in a boxcar," meaning they're so small they will never be noticed. Don't waste time on the BBs in this job until the boxcars are squared away.

Sandbags

- Use sandbags to weigh down stands and tripods on uneven ground, in heavy wind, and in high-traffic areas where stands are at risk of being knocked over.
- They are also useful for bracing set construction. Their weight will solidify set walls and stabilize platforms built from apple boxes. Pile a sandbag or two around an apple box to keep the model from shifting the box accidentally.
- Carry empty sandbags when traveling to locations far from the studio, such as in another city. Use an alternate weight to fill them if sand is not available. Rocks or even potatoes are useful alternatives. There are also weight bags that hold water available on the market. Although they are constructed to be leak proof, I am personally too paranoid to use them anywhere near strobe equipment.
- Don't drop sandbags on the legs of lightweight stands. Fifteen pounds of sudden pressure is enough to bend some of them.

Seamless Paper

- When cutting off dirty sections of paper, start your cut one inch from one side and cut in the other direction straight through to the other side. That single inch will keep the paper from curling while you cut, so you can make a neater, straighter slice. Once the cut is finished, the weight of the paper will tear that inch free.
- If the model will be running or jumping on the seamless, tape down the sides of the paper as well as the front.
- Always roll up seamless tightly to prevent bulges from forming later.
- If the paper starts to crease, let go of it. It will sort itself out without becoming a bigger mess.
- Watch that the subjects, particularly small children, do not step on the swept part of the seamless paper, where it curves from the vertical hanging portion to the floor section. Stepping onto this area might tear the paper or bring the whole thing crashing down.
- Take off your shoes when walking on seamless to avoid leaving dirty footprints behind. Place a scrap piece of seamless or an old showcard next to the paper so models can wipe their feet before walking across the set paper. Another option to keep the paper clean is to lay down a path of cards to the center so you can take meter readings and adjust the model without taking your shoes off.
- Seamless rolls are very long, so watch where you swing them. Try not to knock anything over while moving them around the studio.
- Raising the crossbar once the seamless is on it is difficult. It is best to raise it with the help of another person. Loosen the super-clamps in a coordinated effort and lift both sides at once, being careful not to put too much tension on the paper—you may have to let out some slack from the roll before you lift. If you have to do this alone, let out some slack, and raise each side a little bit at a time.

The following are the steps for putting up and sweeping seamless alone.

- Remove all but one piece of tape from the rolled seamless. Leave the piece of tape nearest the side you will clamp, so you can reach it from atop the ladder.
- Set the ladder on the side you will clamp.
- Insert the crossbar into the roll of seamless and lift one side of the crossbar, resting it in the J-hook farthest from the ladder, as in Figure 9–5.
- Don't put too much side pressure on the AutoPole; it may fall.
- Climb the ladder with the other end of the crossbar and mount the bar into the other J-hook.
- Clamp the bar to the J-hook.
- Remove the last piece of tape.
- Unroll the paper until it touches the floor and rolls up on itself. Stop unrolling just before the paper starts to crease, and clamp the roll off at the top. Clamp the roll to the crossbar and wedge the clamp against the other A-clamp to keep the roll from unraveling.
- Now, pull out the bottom end along the floor a bit, being careful not to start creases, and then use one piece of tape to secure the middle of the paper to the floor.
- Repeat the last two steps until you have the needed amount of paper, and the right angle of sweep.

Set

When shooting in tall grass, walk into frame from the side so you don't leave visible footprints or other signs of your passing.

Set Cart

- No liquids on the set cart around cameras or film. Gently beat that into the photographer's head.

Figure 9–5 Be careful that the crossbar does not slip out of the other J-hook while you climb the ladder.

- Keep the set cart free of dust.
- Keep the set cart orderly. Make a routine out of where you place things on the set cart so the photographer will know where things are when you're not on the spot.
- Keep lenses covered and cameras and film backs closed to avoid dust, scratches, and smoke.
- When on location keep camera cases closed.
- Keep the data sheets and film notes in one place, so the photographer can always find them.
- Move the set cart close to the set for quick access. Stay far enough away to give the photographer room to move around, but close enough to keep stylists from getting into your path from cart to camera.

Slaves

- Keep infrared and normal flash-activated slaves out of direct sunlight. The sun may block the slave from seeing the flash of other strobes or may trigger the strobe unexpectedly.
- Some photographers travel with a slave in every power pack that does not have one built into it. If you pull a slave out, leave it on the pack so it will be easy to find later.
- Check your pockets at the end of a shoot for slaves.
- If flash-activated slaves are not firing the strobe, reverse the polarity; pull it out of the socket and turn it around. If it still isn't firing, try gently spreading the tines wider so they make better contact.
- When a slave is in a position where it cannot "see" the other flashes, attach it to an extension cord and run it to an area where it can pick up the other pops. Take care not to run the cord through any visible areas in the frame. One good way to ensure that the slave sees the other flash is to hang it in front of the other strobe head.
- If radio-controlled slaves begin to malfunction, check the batteries.
- Radio slaves can have their signals disrupted, so always have a hard-wire backup. Never go on location without a backup sync chord.

Stands

- Raise stands from the upper sections first; that way you can always raise it higher from a reachable section.
- Open stand legs as widely as possible for greater stability.
- Stand knobs break more often than any other kinds do. Follow the warnings from the section titled "Knobs" earlier in this chapter.
- Tape down or weigh down stands in high-traffic areas. Remember to watch for clumsy stylists.
- When burdening a stand with a very heavy light, put a sandbag on the base to stabilize it.
- When raising or lowering a section, wrap your fist around the section to be moved just above the knob, as shown in Figure 9–6, so your hand acts as a brake or lock before you loosen the knob. This is easier than trying to hold the weight with your arms when you turn the knob.
- If the stand has wheels, lock the wheels to keep the stand from rolling around.
- In some locations, placement of the stand prevents the legs from being opened all of the way, so use gaffer's tape or bungee cords to attach the stand to something immovable like a railing.

Strobes

- Attach a dog collar to the handle of the power pack so you can hang it on a stand. This keeps the pack from getting kicked over and steadies the stand.
- Learn how to adjust the settings on all brands of strobes, so you can quickly make changes.
- Place packs so that they do not touch each other.
- Remember the previous power settings whenever you change them; photographers are notorious for wanting them changed back.
- Do not change the power setting until the ready light is on. You can damage the strobe guts by altering them while the pack is charging.
- Do not plug too many packs into one electrical circuit or you'll be running to the breakers every five minutes. Also, don't plug them in on the same line as computers. The power surges they create can damage the computers.
- Some strobes, like Dynalite, use the same power cords as computers, so if you find yourself on location and in need of a power cord, strip the nearest computer.
- Sometimes packs go haywire and start firing on their own in rapid succession. Don't panic, just turn off the pack and take out the slave to calm it down. Turn the pack back on and put the slave back in; if it continues, replace the slave with another. If that doesn't work, switch the pack for another one.
- See Chapter 8, "Safety."

Studs

These small fittings, used to mount strobe heads to stands and clamps, are easily lost. Keep tiny items like these in one place when they are not being used. Don't go home with them in your pockets.

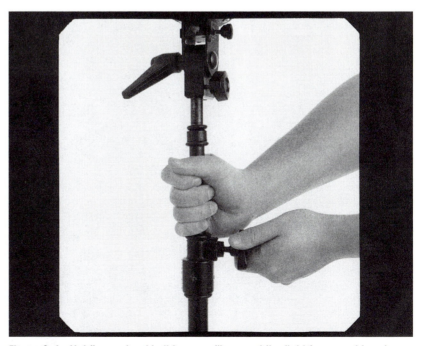

Figure 9–6 Holding a stand in this way will prevent the light from crashing down if the weight proves too much for you.

"Stupid Day"

Every assistant will have a "stupid day" every now and then. This is a day when nothing goes right. Even very experienced assistants will screw up and make mistakes that they haven't made since they were rookies. When an assistant is having one of these days, it is important to slow down and think things through before acting.

I recently had one of my own "stupid days." I picked up the wrong kind of lumber, twice. On my third trip back from the lumberyard, I left the receipt behind. That's one of the cardinal rules of assisting: "Always get receipts." If I hadn't been so humiliated, I would have laughed at myself. Luckily, the photographer *was* laughing.

Subjects and Nonprofessional Models

Photographing people who are not professional models is very difficult. We take for granted when working with pros that they will do what we want and when we want it. When we shoot "real people" we need to coax and trick them into relaxing and giving us what we need. As the assistant, you have to know when to speak up and even more importantly when to shut up; too much talk can distract the subject from the photographer.

A good assistant will learn to get a read on the people being photographed and will be able to tell if the photographer starts to *lose* them. When the person becomes distracted or looks bored, the assistant can then pick up where the photographer left off and revitalize the shoot. Make sure this is okay with the photographer before you chime in; some photographers do not like the assistants to interfere.

Because the assistant is not distracted with the technical considerations of the image, as the photographer is, it may be easier for the assistant to pick up on the subject's moods and engage the person in a conversation that will retain his or her attention. The right comment from the assistant can really salvage a shoot.

For example, one photographer for whom I was assisting was losing the attention of a celebrity during a shoot. I noticed, however, that the celebrity took his dog everywhere and reached down to pet him throughout the shoot, so I asked him about his dog. Immediately the celebrity perked up as he talked about his dog. Knowing the photographer's preference to control the subject himself, I then shut up and let the photographer take over the conversation. The best images were from that latter part of the shoot.

Most people are not comfortable with being photographed. You need a rapport with them to keep a shoot alive. When shooting executives, look around their office to see what personal items they have displayed. If the exec has a golf scorecard or other memorabilia on the wall, talk about that.

Whereas professional talent is accustomed to being poked and prodded, real people are not. You have to be delicate with them. Distract them with conversation while straightening their tie or putting makeup on them, just like a good doctor does before you get stuck with a needle.

Gary Gladstone and I made the perfect tag-team. CEOs are usually pilots or golfers. Gary is a pilot, so he could talk airplanes with an interested CEO, and I play golf, so I kept the golfers interested. Between the two of us, we could keep any executive occupied and happy, while we shot those extra few rolls of film. Just about any executive can be kept at the shoot longer by talking about hobbies.

Tape

Gaffer tape is a fabric-backed tape that sticks to just about anything. Here are a few tips on how to handle it and a couple of other tapes as well:

- Loosen the hold of gaffer tape by applying it to your pant leg to pick up a bit of fluff before sticking it to a surface like a painted wall. If you don't weaken the tape, it will pull the paint right off the wall.
- Don't let the sticky sides of gaffer tape touch each other or you will never separate them.
- Want to see a photographer's hair stand on end? Pull out a big length of gaffer tape and watch the photographer's reaction. The tape is very expensive, and most shooters like you to use it sparingly.
- Paper tape, on the other hand, releases easily and in most cases won't damage the surface to which it is attached. Use it to secure set paper to the floor.
- Since paper tape is cheaper than gaffer tape, use it to bind a roll of seamless.
- The other tape you commonly find in studios is double-stick. This two-sided adhesive tape is useful for taping wardrobe. A bit of this tape behind a tie can keep it in place for the entire shoot without damaging the fabric.

Travel Items

- When traveling on a shoot, pack your personal bag as lightly as possible, but include everything you are going to need plus a little extra, just in case. I travel with a large duffel bag so I can toss in any extra gear the photographer may not be able to fit in the equipment cases, such as muslin backdrops.
- On a typical shoot I pack only enough clothes for each day, plus one nice shirt for dinner. I also pack a rain poncho, wind-up alarm clock, toiletries, aspirin, one extra pair of shoes, a baseball cap, a white bandana, extra Ziploc bags to hold wet clothes or shoes, my daily planner, and my assistant's shoot kit. If the shoot is to be outdoors, I include bug spray and sun block.
- I wear my shoot vest onto the plane so I can shove delicate items into its pockets. In my vest I carry my cell phone and charger, a spare pair of eyeglasses, sunglasses, a pen, and a notepad. I also carry a paperback book, so I don't have to watch the same movie on cable every night, and a snack in case the airline food stinks—but then what are the chances of that? I put my keys or any other metal object that might set off the metal detector and any small odds and ends of the photographer's, like a walkie-talkie, into the vest pockets as well.
- Most hotels provide little soaps, shampoos, and sewing kits with the room. What you don't use during your stay, take with you. You never know when they might come in handy, and their small size makes them easier to carry than the full-sized variety. If you don't like the shampoo, empty the bottle and refill it with your own brand.
- Air travel is hard on shampoo bottles; they often explode or leak. It took me cleaning up a few leaky ones to learn to seal them in a Ziploc baggie. Now I bag up anything that might open up or crumble in my shaving kit. It's not fun doing your hair with a toothpaste laden hairbrush.
- Always keep a toiletry bag packed for your travels. It's much easier to toss this bag into your suitcase when packing than to run around at the last minute looking for all the individual items.

Tripod

- Tape Ziploc baggies to the ends of the legs when working in mud to keep the tripod clean. This will save your having to clean them later.
- Hang a sandbag from the center column to steady the tripod in heavy wind.
- Make sure all leg sections are tightened to prevent the tripod from falling.

Utility/Mat Knives

Use fresh blades whenever possible to make clean cuts. The sectional knives allow you to break off the end section for a fresh, sharp edge. Turn your face away when snapping off a dull section; the tip has a tendency to fly around and you don't want to catch it in the eye.

Vest

I keep so many things in my vest that I sometimes forget what I have in it. One time the photographer and I had sandwiches brought in for the client and us for lunch. The client got very annoyed that the deli had forgotten to put mustard on hers. Just then, my hand brushed against a pocket of my vest and I felt an unusual lump inside. Opening the pocket I realized that it was a small jar of mustard that I had taken from a hotel room several nights earlier. I played it off like I knew it was there and that I always carried one. The client loved it.

Walkie-Talkies

Walkie-talkies are one of the handiest tools to have on a shoot that is spread out over a wide area. These radios allow a photographer to remain in contact with the crew while scouting, or to nag the stylists, back in the location van, to hurry up with the models. They are also useful in an airport baggage claim area to coordinate the search for the equipment cases, which may come out on separate carousels.

Holding a radio also makes you look official and like you belong in restricted areas. Because cops and security personnel carry them, people make the assumption that you are one or the other and don't stop you from doing what you have to do. I know of one photographer who cleared up a traffic jam that would have kept him from making a flight, simply by waving the radio around and directing traffic. With attitude and a walkie-talkie you can get a lot of things done.

No matter how loud things are on your end of a radio, resist the temptation to shout into the microphone. Yelling just distorts the sound at the other end and no one will be able to understand you. If the other person can't hear you over the din, have him or her turn up their volume and cup your hand around your mic to block the noise.

Wardrobe

- Watch from the camera position on fashion shoots for *return*. In most other types of shoots it is not so important, but in fashion it is preferred that this part of the clothing not be seen.
- Use small A-clamps to tighten baggy clothing. Pin the clothing on a side not seen by the camera.

Figure 10–1
These three images are from my first portfolio. Laminated images were "in" back then. There were so many influences on my photography that my portfolio was all over the place.

Figure 10–2
When I was working closely with Gary Gladstone, my work became very corporate-looking. I started to become a Gary Gladstone clone. Still using the laminated prints in my second portfolio.

Figure 10–3
Trying a different look to my presentation in this third portfolio—too many art directors told me the laminations looked like place mats. Again my work changes, but I'm beginning to get my photographers out of my head.

Figure 10–4
The big breakthrough. These are from my latest portfolio.
Quite a change over the previous ones, don't you think?

- Place white paper tape on the bottom of shoes to prevent them from getting scratched, so they can be returned to the store.

Weather

It is very difficult to work in extreme temperatures, both high and low. Apart from precautions you have to take to protect the gear, you have to take care of yourself in these situations. Here are some simple tips to keep yourself comfortable.

- Since you can't wear gloves while loading film, keep a pair of hand warmer packs in your pockets to warm your hands back up after loading. It took a case of borderline frostbite for me to wise up.
- Wear multiple layers of clothing and a hat. Again, I know I sound like a mother, but it does help.
- Know your limits in the heat. Don't push yourself too far; you won't do the photographer any good passed out on the ground.
- Wear loose-fitting clothes that breathe in order to stay cool when the weather is hot and humid.
- Drink lots of water, not soda, to avoid dehydration. If available, have a sports drink like Gatorade.

White Bandana

I bet you're wondering, Why on earth is he mentioning a white bandana? Well, apart from being handy for wiping sweat from your face or hands, you can use it to keep your neck from getting sunburned. Stick one end of the cloth under a baseball cap and drape the rest over your neck, like a French Foreign Legion hat. It may look a bit goofy, but it works. I prefer a white one because it reflects the sun's rays better than darker colors.

Ziploc Bags

Ziploc bags are a great nontraditional photo tool. They are handy for holding film and keeping it dry. I have already mentioned other uses for Ziplocs in the above sections, but there is one more that I should bring up. When you are traveling for a long period of time, you may have to pack your dirty clothes back into your suitcase with your clean clothes. Drop your stinky socks into a big Ziploc bag to separate them from your other clothing. Trust me on this one.

10

Transitioning to Shooter

After putting all of this hard work into becoming a good assistant, you want to chuck it all and start shooting your own jobs? You want to give up the errand running, the cleaning, and the setting up of someone else's shots? You must all be a bit crazy.

I'm kidding, of course. Becoming a professional photographer is the goal of most assistants. But if you thought getting established as an assistant was hard, you're in for a real treat. No matter how good an assistant you are, you have to start at the bottom of the ladder again as a photographer. The information you have acquired and the contacts that you have made as an assistant will give you a steadier footing on that ladder, but as a photographer you will be a rookie once more.

Changing Your Mindset

One of the difficult parts of the transition from assistant to photographer is changing the mindset from that of an assistant to that of a photographer. As an assistant I worked hard to anticipate the needs of my photographers and get things done before the photographer had to ask

for them to be done. Working as a photographer with an assistant of my own is alien to me. I tend to do all of the duties of the assistant as well as those of a photographer, leaving my assistants standing there twiddling their thumbs.

One assistant had to actually grab me by the shoulders and shake me to let him do his job. He told me to go sit down and schmooze with the client like a good photographer while he set up the lights; after all, I had hired *him* to be the assistant. After so many years assisting, it's hard to leave the setup in someone else's hands. It's funny, I used to think I would be a great photographer for whom to assist because I was sympathetic to the needs of assistants. But now I find that I annoy my assistants by not letting them do anything.

Another side-effect of assisting that has presented difficulties to me, as a photographer, is the drive that I developed as an assistant to do everything in my power to make someone else's ideas possible. I forget that now, as the photographer, I have the power to tell art directors that a shot just isn't working their way and to offer them a more reasonable alternative that would answer their needs. Instead, I have worked shots to death, trying to get them done in the way the art director or client wants them done, no matter how unrealistic they were, ignoring better solutions. It didn't even cross my mind to suggest options.

During my first big shoot, for a fashion catalogue, the client asked for a shot that I thought was wrong for the model and the outfit, as well as visually uninteresting. I slaved away trying to make it all happen, working myself into a frenzy in the process. Right from the start I could tell that it would never look right, but I set about *making* it work. An hour into overtime, I conceded to the client that it wasn't looking good. She wanted to know why I hadn't said so earlier. In my assistant's mentality, I was so caught up with making it work, that I never considered suggesting a more suitable alternative. I would have saved a lot of time and aggravation by speaking up earlier, and the client would have been more disposed to changing the shot sooner.

Sometimes you just have to do it *their* way, but as the photographer you have the power to suggest those alternatives. If the clients insist, do it their way, but leave your options open to also shoot it the way you, as the artist, feel is better. It's not an easy task to talk clients out of an idea once they have it in their heads, but it's your responsibility as a photographer to know what you are capable of doing, so speak up.

Your Photography

It's a bit demoralizing to go from being trusted and respected assistants, who have control over their world, to unknown and untested photographers adrift in a sea of confusion and doubt. You just can't tread water and hope the rescue ship finds you. Assisting will teach you how to swim, but you have to decide *where* to swim, and which stroke is best for you.

For a long time I splashed around in circles, following one swimmer and emulating that swimming style, only to change strokes and direction to follow another, but never really getting anywhere. Only recently have I developed my own stroke and picked a direction in which to swim. Now that I know where I am going, I can use what I learned from others to help me get there more easily.

Tired of this swimming metaphor? Okay, I'll be more specific. Three photographers have been big influences on my photography. While assisting for them, I built portfolios around an emulation of their styles, at times including all three styles in my book. Although I feel they were all good images, art buyers never knew how to categorize me, or which style they were going to get from me, so they shied away. Since I wasn't committed to a direction, I couldn't bring to bear any of the lessons I had learned about promoting myself, or make full use of many of the more valuable contacts I had made. It took an experiment in shooting personal work with another photographer, and the advice of an excellent consultant, to find my own unique style and direction. (See Figures 10–1–10–4 in color insert.)

When you feel yourself floundering, the right consultant can help you get back on track or suggest that you change your approach entirely to a more effective one. I am lucky to have had a working relationship with a photographer's representative and consultant for many years. Elyse Weissberg reps one of the photographers for whom I have assisted from the beginning of my career. Not wanting to infringe upon that professional relationship, it took me until three years ago to approach her to consult with me.

It was the best money I ever spent. She helped me tighten the focus of my portfolio, improve my presentation, and develop a promotional strategy. My portfolio really started to come around, and I was beginning to feel good about what we had put together, when something remarkable happened. I walked into Elyse's office one day with a couple of images that I had shot for myself while on the road with another photographer and showed them to her. She looked them over, and then looked me straight in the eye and said, "You're not going to want to believe it, but *this* is your portfolio."

I didn't want to believe it. After the time and effort we had put into the current portfolio, all of a sudden I was facing changing it all once again. I stomped off home and sat down to think it over. I laid out all of my images from the current portfolio and the new work, looked at them for a long time, and came to the conclusion that she was right. The new stuff *should* be my portfolio. It spoke to me; it meant something to me inside that the other images didn't. I would never have had the courage to consider it if Elyse, as a consultant, had not suggested it.

The work that I had put together, emulating the photographers for whom I worked, was all a part of my journey. They were experiments in making images for me. Those influences helped me develop a visual language, and once I was able to reduce them to background whispers in my head, I was able to find my own voice. I used to think that all the fancy, industry talk about style and visual language was preachy nonsense, but once I started making the images that meant something to me, personally, I saw the merit in what some of the "experts" were saying. You have to commit part of *yourself* to each of your images.

I have been lucky in my career as an assistant to work with some great people. Through the years they have been emotionally supportive as well as materially helpful. The photographers with whom I have worked closely have been very giving of their advice and the occasional piece of equipment or studio space. Through working with them, I made my most important contacts that have aided my advancement.

Consulting with Elyse Weissberg has made the greatest impact upon my development as a photographer. She is the rep for one of my

photographers, and as I said before I have known her for many years. When I reached an impasse with my portfolio and progression as a photographer, I prevailed upon her to consult with me. Her expertise helped me refine my portfolio at the time, and she guided me through the process of self-promotion and looking for work as a photographer. When I made the breakthrough with my current work, she gave me the push I needed to continue. I can't sing her praises enough to equal what she has done for me.

I recently asked Elyse for some advice to give you as emerging photographers on making this transition from assistants to photographers. As always she was very forthcoming and helpful with this information. She believes emerging photographers are lucky to be able to have assisting to fall back on to make the money necessary to finance the transition, and that they should not feel that by doing this they are going *backwards* in any way. Assistants should start their professional portfolios and their marketing strategies while they are still assisting; emergence as a working photographer is a year-long effort in the best case scenario.

Elyse then told me a story of an assistant who recently came to her looking to make this transition, and his situation had striking similarities to my own. All of the images in his portfolio were imitations of the work of several of his photographers. On one level, emulating another photographer's style is a good thing; it teaches young photographers techniques and opens them up to learning what they like as image-makers. But it does not aid in maintaining a consistent look to the portfolio.

This assistant didn't know *what* he wanted to shoot. Boy, do I know that feeling! Elyse told him, "Do a shoot. Walk around the block and shake off those other influences. Shoot something for *yourself*."

She told him he had to find his own point of view. He was not to compose the image in his head before he shot, but to work it with his soul. "Use your cumulative knowledge only to aid you in expressing your own viewpoint." Elyse is emphatic when she says, "Pay attention. Don't see your work in terms of categories. It's not important *what* you shoot, but *how* you shoot. Remember that." Once the assistant had done that, he could compare the two bodies of work and add any appropriate images from the old one to his new work to start building a portfolio that was *his*.

Elyse then suggests to pull ten magazines off the shelves and look for editorial and advertising content that is akin to your own photography style. "It helps to know there are people out there who have a use for your style of work. Use those magazines as a database to empower you to continue."

I also asked Elyse for a few tips on portfolio presentation. She was amenable to most presentations as long as they were up to professional standards. They should be neat and clean, use nice materials, and the elements should all be of a consistent size. Since more and more photographers are now using digital prints, they are gaining wider acceptance in portfolios. In practical terms, stay away from heavy or bulky cases and keep in mind that they should fit into a FedEx box for easier shipment. These are rather blanket statements, but they should help give you a start.

Contacts

Once I had developed my new portfolio, one of my other photographers put me together with her new rep. Michael Pape was a recent arrival on the scene and looking to expand his stable of photographers. He was impressed with my new work and decided to give me a try. After getting some terrific responses with my portfolio, he decided to formally represent me.

I can't tell you how great a feeling that was to have a rep think enough of my work to want to represent me. Over the years I have had my older portfolios in front of several reps and been disappointed by their reactions. They looked them over, smiled compassionately, patted me on the head, and sent me away. Having Michael be so confident in my work that he wanted to rep me made me feel ten feet tall.

Together with the five other photographers handled by Michael, under the aegis of Pape Artist Representation, we are developing a group identity and promotional campaign, complete with sourcebook ads and promotional mailings. For me, being part of this group has been a godsend. It's tough out there on your own. Financially, it is advantageous to be part of a group; many suppliers provide bulk discounts. When you are just getting on your feet, every penny counts. It takes money to make money in this business, so it helps to be able to save wherever you can. Also, I think being part of a group of talented photographers affords me greater access to art buyers than if I was a lone straggler.

Having a rep is not for everyone. Some photographers prefer to go it alone. But as with many photographers, I am not at ease with promoting myself to art buyers, so having Michael handle those affairs is a weight off my shoulders. My work gets in front of many more art buyers than I would be able to see on my own, and it is accompanied by someone more able to really *sell* it than I could. Michael has really gotten some promising attention to my work.

Through my association with certain photographers, I have been able to make other contacts that have benefited me greatly. My work with these people and photography organizations has brought me to the attention of equipment and film companies. Mamiya, Polaroid, and Kodak have been very generous in their support of my educational programs for assistants. Without their help, many of those programs and seminars would not have been possible.

They have shown the foresight to know that assistants are the future of this business, the photographers of tomorrow. I have met some wonderful people at these companies who have been supportive not only of my efforts on behalf of assistants, but of my own photography career as well. These contacts have contributed to my development as a photographer and made clearing many of the hurdles in this industry easier.

Even the opportunity to write this book, no matter how helpful to assistants it should prove, would probably never have happened had it not been for the contacts I made while assisting another photographer with his latest book. I was never ambitious enough to write a book until a suggestion from his publisher got me moving. Let me tell you, this isn't easy.

In a way, writing this book has helped me put my career, both as an assistant and as a photographer, in perspective. Even experienced assistants can get cocky and forget why they were hired—to do whatever the photographer needs to be done.

I've remembered things that I thought I had forgotten, and it has helped me focus on the road ahead. I hope this book will help me take that next step up the ladder. Having published books of your work out there is another way of promoting yourself in this industry. You never know who might see them and send some work your way.

Making Your Move

Right now I am in that awkward limbo between assisting and shooting; I shoot about as much as I assist. This transitional stage is perhaps the hardest for most assistants. It's like sticking your toe into a pool of water to see how cold it is. It's safe and warm where you're standing, but you really want to go swimming—only you're not sure if you're ready for the cold. I'm not so brave as to dive in headfirst, but I'd say I've waded up to my waist now, feeling that first real sting of the cold water. It's scary to be a rookie once more—a rookie photographer, that is. I have to prove myself all over again. I haven't built up a reputation, yet, as a photographer. Whereas I am known around town as a good assistant, not many really know me as a photographer.

My rep and I are tackling that first obstacle now. With the promotional ads and the mailings, we are introducing ourselves to the industry. No one will hire me as a photographer unless they know who I am and what my work is like, so these promotions are giving them a first taste. Michael follows up these promotions with personal visits or drop-offs to show these art buyers and designers the rest of my work. It's a long process, but I feel we are starting to get some attention. We have targeted some specific magazines and agencies that use work similar to mine, and we are sending them promo cards and taking the portfolio around to them. Art buyers and art directors whom I have met over the years at parties or workshops are also on the list. Any buyer with whom I have had contact—as long as there is no conflict with my photographers—is pitched.

What comes after this is anybody's guess. We hope to land some good shoots and repeat clients. It's hard to remain optimistic at this point of the transition. What I don't know about getting work as a photographer could fill volumes; it's unnerving, having to wait and see what happens next. I'll let you all know how well the transition goes in the next book I write.

There is no sure way to success as a young photographer. I only wish there were, then I wouldn't be awake till four o'clock every morning stressed out and staring at the ceiling wondering why I haven't gotten any calls in response to my sourcebook ads or mailers. It happens differently for everyone. What works for one photographer can bomb for another. It seems like you just have to try things that *might* work, and if they don't, move on to something else.

I'm not going to join the ranks of the many "false prophets" out there and tell you that if you do things *my* way you will find a sure path to success. I don't know the best way to get established as a photographer—I'm working on that myself, now. This may sound a little bleak, but I prefer to tell you how it really is. Pay attention to what other photographers are doing to promote themselves and then try

adapting those strategies to your own uses to start. Hiring a designer to create a presentation and promotional materials is also an option, but you're going to have to discover what works best for you, on your own. If you ever do find that surefire promo, call me; I could use some help myself.

I hope that I have been of some help to you in learning how to be a good photographer's assistant. This book is not meant as a substitute for actual assisting experience, but as an aid in getting started in the business and to help you get over some of the rougher patches that you will come across on the road to becoming photographers. Assisting should be looked upon as a journey of learning. All of the information that you pick up along the way can be used to build the foundations of your photography career. There is a direct relationship between being a valuable, hardworking assistant and the quality and quantity of information that others will give to you. The better an assistant that you are, the more access you will be given to attain the knowledge that you will need, both as an assistant and as a photographer. Good luck.

Glossary

There are many pieces of photo or grip equipment that are used in this industry that have odd names and unique expressions that you will have to know to understand what photographers are saying to you. Though you will pick up on most of these after only a few days assisting, this Glossary should help you get a jump-start on the lingo.

1K, 2K Nicknames for 1,000- and 2,000-watt continuous hot lights. "K" stands for kilo-, or thousand.

A-Clamp Spring-loaded clamps that are shaped like the letter "A."

Apple Box These multipurpose wooden boxes are strong enough for a person to stand upon. There are several sizes, the full size being 18" × 12" × 8"; a half apple is half as thick, and so forth.

APA Advertising Photographers of America.

APNY Advertising Photographers of New York.

Arc To create a bridge of electricity between two conductors, as in arcing a strobe pack by removing a head cord while the pack is charged. See the chapter on safety.

Arc-Proof Some strobe units are designed to prevent a dangerous arc of electricity from forming when a strobe head is unplugged from a strobe power pack while in a charged state; they are referred to as arc-proof. See the section on "Electrical Safety" in Chapter 8 for more details.

Arc-Resistant Some strobe units are designed to reduce the chance of an arc. On the advice of a trusted retailer, I still turn the pack off before unplugging the head cord from these packs.

Armature Wire Flexible metal wire of varying gauges used to rig items on set. Useful for positioning small objects at odd angles.

ASMP American Society of Media Photographers.

AutoPole Brand name now commonly used to describe all similar sectional poles that wedge between floor and ceiling. Most often used in pairs from which to hang backdrops.

Back Medium format camera film magazine, the detachable section of a medium format camera that contains the film.

Backdrop Any material hung or erected behind the subject on set.

Ball Head The top of a tripod upon which the camera is attached that can be tilted in almost any direction. Unlike traditional tripod heads that have up to three knobs, one controlling each direction of tilt or swivel, ball heads allow the camera to tilt or pan in any direction by loosening just one knob.

Barn Doors Wide metal plates that attach to light sources that can be adjusted to reduce the angle of dispersion of light.

Beauty Dish Wide, flat reflector used on strobe heads.

Book Another name for a photographer's portfolio.

Book Flat Two four-by-eight-foot foamcore boards taped together along one long side to form a free-standing fill card shaped like an open book.

Boom A long pole balanced horizontally across a vertical stand. Useful to extend lights over the top of a set while the base remains out of view of the camera.

Butterfly A large square frame across which fabric is stretched; used for diffusing or blocking sunlight.

Call Time Scheduled arrival time for you and all members of cast and crew on the day of a shoot.

Camera Stand An alternative to mounting a camera on a tripod, this stand has a tall central pole and a weighted base that rolls smoothly around the studio.

Casting Job interviews for models.

Clip When processing film a photographer may opt to have the lab cut off part of a roll of film and process it a certain way; this is called a Clip. The remainder of that roll is called the Balance. By clipping a roll, the photographer can determine how the rest of the film should be processed. Because the film is actually cut somewhere along its length, one or two frames may be damaged. A Front Clip means the photographer wants the clip to be made at the beginning of the roll, and a Tail Clip is from the end of a roll of film. Accurate film notes will help the photographer determine which end is appropriate to cut.

Collar Also known as a Grid Holder. This is a round metal frame that fits on the front of a strobe head to hold grids in front of the light.

Cookie Also known as a Cucoloris, named after its inventor, this is a rigid panel with irregularly shaped cutouts, through which light is shone to create dappled light patterns.

C-Stand Also known as a Century Stand, the staggered leg design allows these stands to be placed close together.

CTB Stands for Color Temperature Blue. These blue lighting gels come in Full, ½, ¼, and ⅛ densities. A Full CTB converts tungsten colored light to daylight.

CTO Stands for Color Temperature Orange. Also known as a warming gel. A Full CTO converts daylight-colored lights to tungsten color. They come in the same densities as CTB: Full, ½, ¼, and ⅛.

Cutter A card or board used to block light from landing on an object or area.

Dark Cloth The black cloth photographers use to cover their heads to block light so that the image on the ground glass of a view camera is more easily seen.

Data Sheet The form on which assistants write film notes.

Dish The bowl-shaped reflectors mounted on some strobe heads.

Dots The little round sticky labels used to label film.

Drop-Off Term used for leaving a portfolio at an agency or firm for later viewing by someone, such as an art buyer or designer. Generally the portfolio is left in the company's mailroom or with a receptionist.

Dust-Off Brand name for canned air used to blow dust from an object.

Fill (1) To add light to a dark area. (2) The reflective card or light used to add light to a dark area, also called a Fill Card.

Film Notes Details of a photo shoot written on the data sheet, including exposure, lens used, description of image, and processing directions.

Filter Glass or plastic attachment placed in front of a camera lens to alter the color density or clarity of an image.

Flag Rectangular frames with a mounting pin and covered with dark cloth. Used to eliminate flare from lenses by being placed between the lens and the light source. A flag can also be used as a cutter.

Flats Usually four-by-eight-foot wooden frames covered on one side with a quarter-inch-thick sheet of plywood, used for set wall construction. Also handy in a pinch as a lunch table.

Flex Fill Brand name now used to describe all similar products. They are disc-shaped fabric reflectors that curl up for easy storage and transportation.

Floor Stand A light stand with legs that lie flat on the ground with no central column, allowing a light to be secured at ground level. Some floor stands have optional extension poles to raise the light as desired.

Focusing Spot A specialized strobe head that narrows or shapes strobe light so that very small areas may be lighted without affecting the whole set.

Four-by-Eight A four-by-eight-foot sheet of rigid, lightweight foam covered on both sides with either reflective white or matte black paper.

Frame Everything within the angle of view of a camera lens. An object is considered "in frame" when it is visible through the viewfinder of a camera.

Frog A small, green, metal plate with numerous nails attached to one side used to hold small fill cards on a tabletop set.

Fun-Tak Sticky green putty that adheres to most surfaces but is easy to remove. Used to hold small fill cards or other small objects in place.

Gel Thin colored sheets of plastic placed in front of light sources to alter the usual characteristics of that light, such as color or sharpness.

Genny An electrical generator.

Gobo No one has ever adequately explained the origin of this word, but it is a card or flag used to block light from striking the lens to prevent lens flare.

Grid Honeycombed discs that are placed in front of strobe heads to narrow the beam of emitted light.

Grip Arm A short pole with a circular clamp on one end to hold objects such as gobo cards and flags. The other end of the pole is sized to fit into most strobe heads, making it useful as a mini-boom.

Grip Case The container used to transport or store equipment, such as clamps, studs, tape, and other small set-related gear.

Ground Glass The frosted glass through which an image is viewed on a large format camera.

Hair Light The light directed upon a person's head and shoulders from above and behind a subject.

Head (1) The portion of a strobe unit that contains the flash tube and modeling light. (2) The top section of a tripod.

Head Extension The electrical cord that runs from the strobe head to the strobe pack.

High Boy A very tall, sturdy, and often wheeled stand. High boys are used to hold very heavy lights, backdrops, and large scrims and butterflies.

Home Economist A food stylist.

Hot Light A continuous light source, unlike a strobe that emits a burst of bright light. Because it burns brightly at all times, it generates high temperatures, thus the name.

J-Hook A small metal fitting shaped like a letter "J" with a pin at one end; used to suspend crossbars.

Knuckle A circular clamp mounted on top of stands to hold grip arms. Also known as a grip head.

L-Bracket A piece of hardware shaped like a letter "L" and used to brace objects.

Light Bank A rectangular fabric "box" of varying sizes mounted onto strobe heads. The front is a panel of sheer material that softens the hard light of a strobe flash into a broad, diffused light. Also known as a Soft Box.

Lightbox A tabletop light fixture with daylight-balanced fluorescent light tubes under a sheet of translucent Plexiglas used to view transparency film.

Lens Tissue Special tissue used in combination with lens-cleaning fluid to clean the glass of camera lenses. Use this instead of your T-shirt to get dust off a lens.

Loupe A small magnifying glass used to view film.

Misfire A failure of the strobes to flash when the camera shutter is released.

Modeling Light The dim, continuous light in a strobe head that allows a photographer to see the light on the subject in between flashes and to focus the camera.

Net Similar in appearance to flags, netting is stretched over the frame to reduce the amount of light passing through it rather than block it.

Pack The power storage and control portion of a strobe unit.

Pencil Tube A narrow strobe tube without the protective housing or cooling fans of a strobe head. Because of its small size, it is often rigged inside a lampshade so its flash will appear to be the natural light of the lamp.

Pigtail The short cord built into certain strobe heads that connects to the head extension cord. Strobe heads pack more efficiently without long cords permanently attached.

Plexi Short for Plexiglas, sheets of clear or frosted plastic used as tabletops, backgrounds, and sometimes floors on set.

PPA Professional Photographers of America.

Promo Card Cards printed with samples of a photographer's images, name, and contact information used as "leave-behinds" or as mailers sent out to prospective clients.

Prop Houses Large warehouses of items available to rent for use in photographs, such as furniture, toys, and so on.

Props Any object used in a photograph that is neither the product nor the subject of an image.

Pull To decrease processing time. For example, if a test frame is a half stop too bright, a photographer might pull the rest of the film by a half stop to get the correct exposure. Pulling a half stop is denoted as $-\frac{1}{2}$.

Push A push is the opposite of a pull. Film is pushed to lighten a dark image. A push of a half stop is denoted as $+\frac{1}{2}$.

Quick-Release Pad and Plate A combination that allows a camera or lens to be mounted to and removed from a tripod quickly and easily. A small metal plate that is screwed into the bottom of the camera fits securely into the pad, or base, that is permanently mounted onto the tripod head. A simple knob or lever locks the plate into place on the pad.

Radio Slave A transmitter and receiver set that allows a strobe to be fired by means of a radio signal. Use of a radio slave eliminates the need for a long sync cord or the need for the line of sight necessary for optical flash slaves.

Raw Film Term used to describe unexposed film.

Reflector (1) A card or material used to bounce light from a light source onto an object or area. (2) The bowl-shaped attachment used on strobe heads with protruding flash tubes to direct light forward instead of all around.

Return This is a term most commonly used in fashion photography to describe the fabric on the far side of a garment. For example, if a model wearing a skirt were facing camera, the *return* would be the material of the skirt that wraps around the back of the model's legs. It is often considered undesirable to see return in fashion shoots.

Rig To fit equipment together for use.

Roll Film 120mm film used in medium format cameras.

Schmooze A Yiddish expression meaning to chat idly or to cajole. Like many Yiddish expressions, the word sounds just like the meaning.

Screw Gun A cordless drill and screwdriver.

Scrim A panel of sheer fabric used to diffuse light passing through it; similar to a butterfly, only smaller in dimension.

Seamless A roll of background set paper, available in many colors and widths (4 feet, 9 feet, and 12 feet).

Set Cart A wheeled workstation in which grip equipment, such as tape, clamps, and film, is stored. The top surface is often used for loading film and taking film notes.

Sharpie A brand of permanent marker that dries quickly on most surfaces. Commonly used to label film and Polaroids.

Sheet Film $4 \times 5''$ or $8 \times 10''$ film. Each individual piece of film is known as a sheet.

Shot Film Exposed film. Protect this film at all costs.

Showcard A thirty-by-forty-inch piece of cardboard used as a reflector or a cutter; available in several colors and degrees of reflectance.

Silk The sheer diffusion fabric stretched across the frame of a butterfly or scrim.

Slave An optical, infrared, or radio wave trigger used to fire strobes remotely.

Snoot A metal tube attached to the front of a light to narrow the beam of light emitted; also known as an angle reducer. Used to direct light to cover only a small area.

Speed Ring The mounting device for a light bank. The ring rotates on the strobe head so that a rectangular light bank may be positioned vertically or horizontally without removing it from the strobe.

Steam Chips Substance that dissolves into vapor when added to water to give the appearance of rising steam.

Steamer A piece of equipment that heats a tank of water into steam and is used to remove wrinkles from fabric.

Strip Bank A light bank with a narrow front panel. It still provides a diffused light, but is less broadly dispersed than a traditional light bank.

Stud A small metal pin used to mount lights to various stands and clamps.

Super-Clamp A heavy-duty clamp with jaws that ratchet closed. Its accessory hole holds studs and J-hooks firmly enough to suspend strobes and crossbars while the jaws grip other stands and poles.

Superwide A twelve-foot-wide roll of seamless set paper.

Sync Cord The cord that connects a strobe to the camera. A signal passes through the cord to fire the strobe when the camera shutter is released.

Sync Extension A lightweight cord that extends the reach of a sync cord from camera to pack.

Test Roll A separate roll of film with samplings of numerous shots, or test frames, that is processed prior to the rest of the exposed film. A photographer can then determine the best processing directions for all the represented shots. Shooting a test roll avoids the damaged frames associated with clipping film.

Timber Topper A spring-loaded cap attached to a long piece of wood that holds the board tightly between floor and ceiling. Similar to an AutoPole in function, items can also be screwed into this brace to hold set walls upright.

Toe Line A mark or piece of tape place on the floor to mark a model's position.

Tough Spun A particular type of diffusion material used in front of lights to soften the quality of light emitted.

Trigger A radio or infrared slave transmitter.

View Camera A large format camera.

View Finder The eyepiece of a camera through which a photographer views an image.

Wattsecond Amount of energy expended in a strobe flash. Strobe units rate their amount of power in terms of wattseconds; a 2,000ws pack is twice as powerful as a 1,000ws pack. Wattseconds are directly proportional to f-stops: reducing the strobe power setting by half, for instance, cuts down an exposure reading by one stop. For example, cutting back on power from 1,000ws to 500ws would drop a hypothetical exposure from f-11 to f-8.

Winnie Location van or motor home that is used to carry equipment and crew to a location. This is the base of operations for many exterior location shoots, where the models get made up and change wardrobe and excess gear is kept.

Wrangler Special handlers are necessary on certain shoots to control animals or children. These wranglers entertain the subject before the shoot and control or coax them once on set. They are specially trained in getting responses from the animal or child. Some of the child shoots I have been on could have used an animal wrangler with a leash, instead of a child wrangler.

There are some expressions that photographers use that are slightly ambiguous, so I thought I would translate them for you. I hope these help you understand your photographers a bit better.

Miscellaneous/Useful Expressions

"A shot in the can," refers to a finished shoot.

"Give it a pop," means to fire, or trigger, the strobes.

"No fire," means the strobes failed to flash when the camera shutter was released.

"One more roll," means the photographer is just going to keep shooting until he feels like stopping. When you hear this phrase be prepared to open more film and to continue the shoot. It rarely means just *one* more roll.

"Should be a short day today." Don't you believe it; photographers will always find something for you to do that will extend your day. There's always "one more thing before you go."

"Strike the set," means take the whole set apart, cameras, lights, props, and backdrops, and put them away neatly where they belong.

"Thingys, Whatsits, and Doohickeys." All of the above, depending upon which photographer you are assisting at the time. You'll just have to learn which item the photographer means.

With that being said, I think I will now strike set and get back to where I belong, on set with my photographers. I have an early call time tomorrow and I have to catch up on lots of lost sleep. Good luck to you all.

Bibliography

Gladstone, Gary. *Corporate and Location Photography*. Rochester, NY: Silver Pixel Press, 1998.

Reznicki, Jack. *Illustration Photography*. New York: Amphoto, 1987.

Index